GUINNESS WORLD RECORDS

THE WORLD'S BIGGEST EVERYTHING

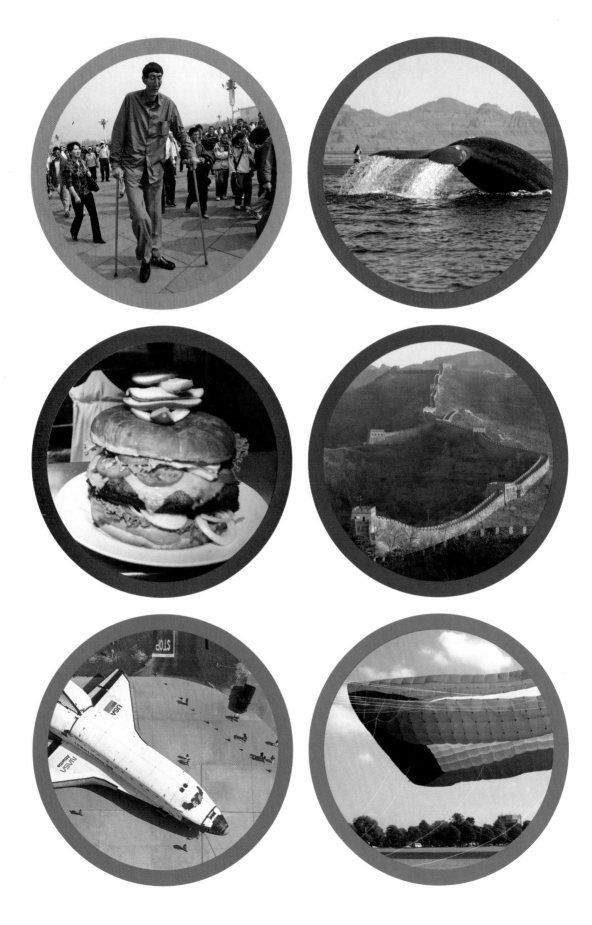

GUINNESS WORLD RECORDS

THE WORLD'S BIGGEST EVERYTHING

Guinness World Records:
Laura Barrett, Stuart Claxton, Craig Glenday, Laura Jackson, Ben Way

Go to www.guinnessworldrecords.com
to learn how you can be a record-breaker!

Time Inc. Home Entertainment

Richard Fraiman, Publisher; Carol Pittard, Executive Director, Marketing Services; Tom Mifsud, Director, Retail & Special Sales; Swati Rao, Marketing Director, Branded Businesses; Peter Harper, Director, New Product Development; Steven Sandonato, Financial Director; Dasha Smith Dwin, Assistant General Counsel; Emily Rabin, Prepress Manager; Jonathan Polsky, Book Production Manager; Anne-Michelle Gallero, Associate Prepress Manager; Alexandra Bliss, Assistant Marketing Manager

Special Thanks:
Bozena Bannett , Glenn Buonocore, Suzanne Janso, Robert Marasco,
Brooke McGuire, Chavaughn Raines, Ilene Schreider, Adriana Tierno, Britney Williams

Produced by Shoreline Publishing Group LLC

President/Editorial Director James Buckley, Jr.
Designer Tom Carling, carlingdesign.com
Production Coordinator Tina Dahl

Text for this book was written by James Buckley, Jr., based on records from
the Archives of Guinness World Records. See final page for photo credits.

10 9 8 7 6 5 4 3 2 1 6 7 8 9 10

Printed in the United States.

The World's Biggest Table of Contents

Well, not really, but this does list all the really **BIG** sections of this tremendously **HUGE** book!

One Big World

It's a big world out there, but some things are just bigger than others. In this book, we celebrate the world's biggest, largest, tallest, mostest (okay, not mostest, but you know what we mean) everything. It's all thanks to dedicated record-setters and the busy record-keepers at Guinness World Records. For more than 50 years, they've been tracking records big and small, short and tall. Visit their Web site at www.guinnessworldrecords.com to explore more amazing records.

Meanwhile, in this book, you'll meet the **WORLD'S TALLEST MAN** (page 10) and see the world's biggest bird (page 42). Imagine trying to eat the **WORLD'S LARGEST HAMBURGER** (page 61) and picture yourself diving into the **WORLD'S LARGEST BOWL OF PASTA** (page 65). Climb the **WORLD'S HIGHEST MOUNTAIN** or the **WORLD'S TALLEST LIVING TREE** (page 87). Take a ride in the **WORLD'S BIGGEST PICKUP TRUCK** (page 110).

And what book about "biggest" things would be complete without the **WORLD'S BIGGEST RUBBER BAND BALL**, **CELL PHONE** or **YO-YO** (all in the "Grab Bag" chapter).

Some of the record-setting big things in here came about through acts of nature (icebergs, oceans, trees). Others came through sheer determination (fingernails, weightlifters, X Games champs). Still others combined creativity with skill and patience (rubber band balls,

MEASUREMENTS IN THIS BOOK

Both "English" and metric measurements are used throughout this book. Here are what the various abbreviations mean:

English		**Metric**	
ft.	*feet*	*mm*	*millimeters*
in.	*inches*	*cm*	*centimeters*
oz.	*ounces*	*m*	*meters*
lbs.	*pounds*	*km*	*kilometers*
yds.	*yards*	*sq km*	*square kilometers*
mi.	*miles*	*g*	*gram*
sq. mi.	*square miles*	*kg*	*kilograms*
mph	*miles per hour*	*ml*	*milliliters*
gal.	*gallons*	*l*	*liters*
		km/h	*kilometers per hour*

BONUS INFO

In circles like this one, look for additional records, more information on the main record, or just something cool to read.

piercings, burps). Through it all, you'll see photos of these records setters as well as hear the inside stories of how some of them came to earn their record-setting status.

Look for bubbles like this one to find out even more record news.

Some of the features of this book are described on these two pages, such as our handy size comparison graphic (below) and the two types of "bubbles" that will pop up throughout the book. And don't forget to track how you do on the trivia questions on the bottom of most record pages.

As you begin your big trip through this exploration of the world's biggest, stop every once in a while and think about how you fit in. Are you bigger than some of these things? How much bigger? Are there any "big" records that you—alone or with, well, thousands of friends, in some cases—might like to try to break? If you do try, best of luck (and be careful!) and maybe we'll see you in the Guinness World Records book some day. The big annual book, that is!

SIZE COMPARISON CHARTS

In this book, graphics compare the "big" object to the things at the right. For instance, this graphic compares the Bigfoot monster truck to three kids standing on each other.

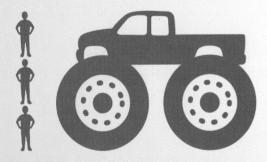

3:1 It would take you and two friends to equal Bigfoot's height.

This figure represents one typical kid; or 4 ft. (1.2 m)

Here's a typical kid lying down—still 4 ft. (1.2 m), though.

Half a kid? No, it's a toddler, the same as 2 ft. (0.6 m).

We sometimes use this symbol when comparing things to hands.

A football? No, this symbolizes a football field, which is 100 yards (91.4 m) long.

A school bus is a familiar site to most kids. We use this symbol to equal a bus, or 40 ft. (12.2 m).

WHAT IS THIS SECTION OF THE BOOK CALLED AND WHAT WILL READERS FIND IN IT?

This is where you will find a trivia question (and its answer) about something relating to the information on the page. Good luck!

7

People

Let's start our world tour of the world's biggest everything with the things we know best: Ourselves! In this chapter, find out the amazing things that human beings can be and do.

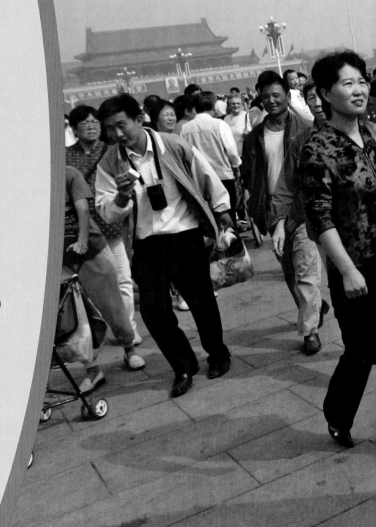

WORLD'S TALLEST MAN

Not surprisingly, when Xi Shun goes for a stroll in his native China, people stare. He's the World's Tallest Living Man (page 10).

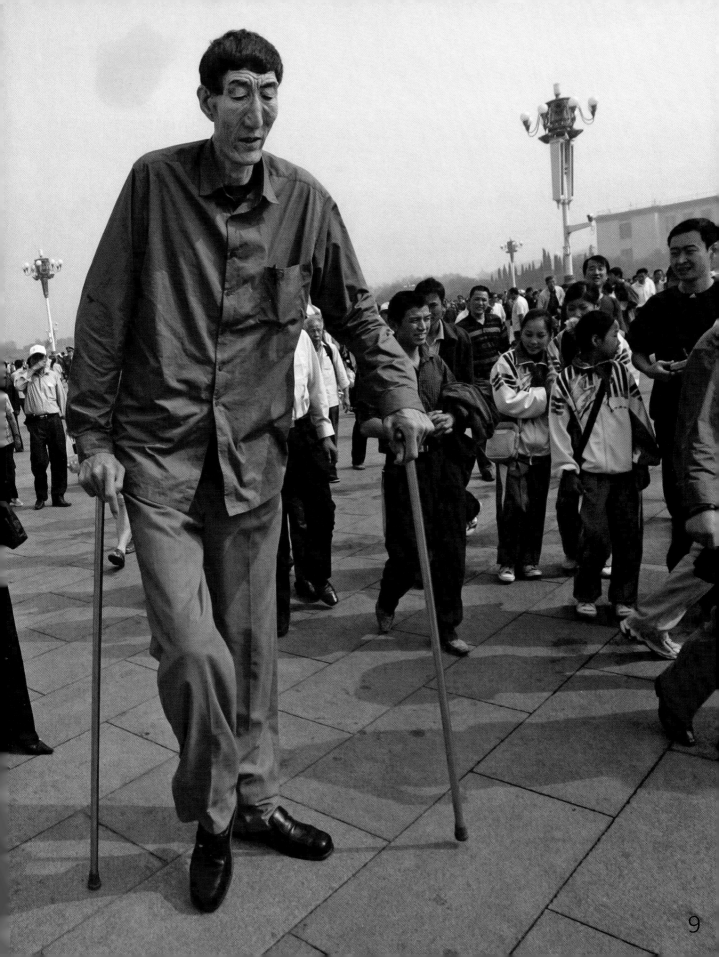

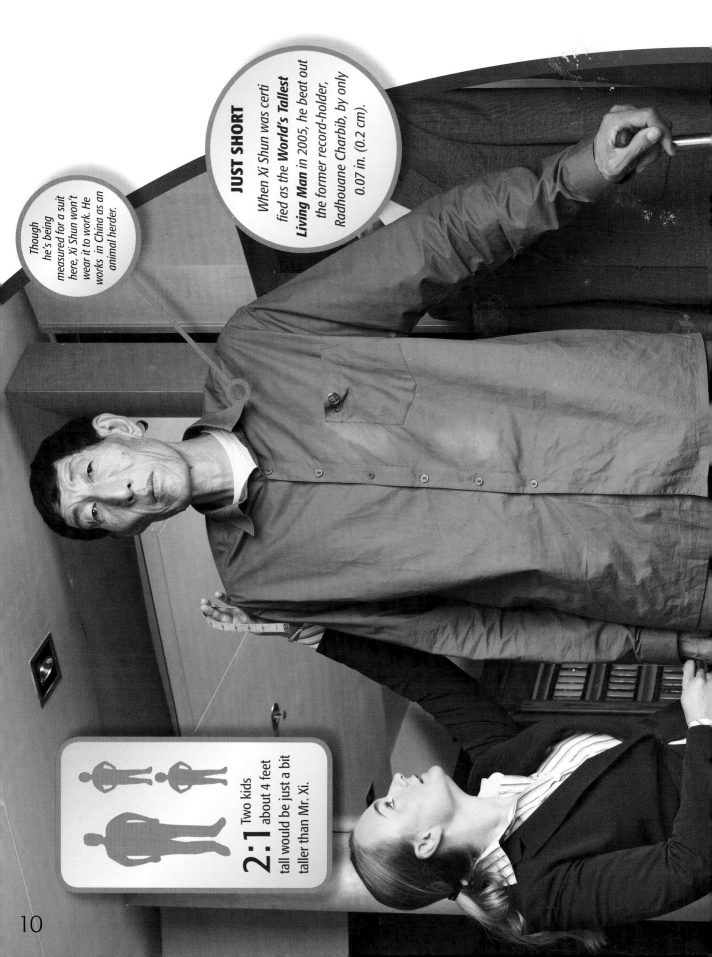

Though he's being measured for a suit here, Xi Shun won't wear it to work. He works in China as an animal herder.

JUST SHORT

When Xi Shun was certified as the **World's Tallest Living Man** in 2005, he beat out the former record-holder, Radhouane Charbib, by only 0.07 in. (0.2 cm).

2:1 Two kids about 4 feet tall would be just a bit taller than Mr. Xi.

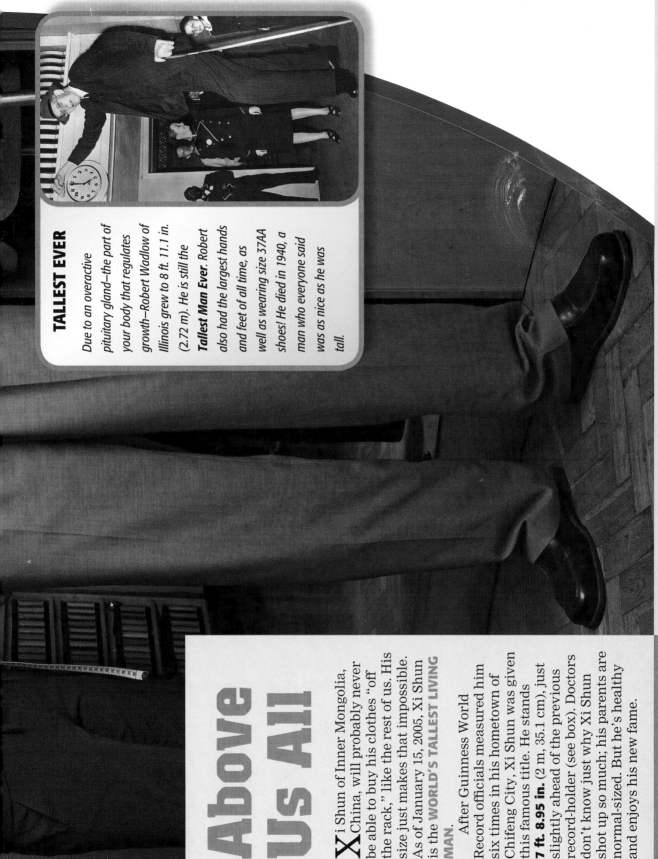

XI SHUN WAS IN THE CHINESE ARMY, WHERE HE PLAYED BASKETBALL. HOW HIGH IS A BASKETBALL RIM?

Xi Shun would have no problem dunking without jumping; a hoops rim is 10 ft. (3 m) from the ground.

TALLEST EVER

Due to an overactive pituitary gland—the part of your body that regulates growth—Robert Wadlow of Illinois grew to 8 ft. 11.1 in. (2.72 m). He is still the **Tallest Man Ever.** *Robert also had the largest hands and feet of all time, as well as wearing size 37AA shoes! He died in 1940, a man who everyone said was as nice as he was tall.*

Above Us All

Xi Shun of Inner Mongolia, China, will probably never be able to buy his clothes "off the rack," like the rest of us. His size just makes that impossible. As of January 15, 2005, Xi Shun is the **WORLD'S TALLEST LIVING MAN.**

After Guinness World Record officials measured him six times in his hometown of Chifeng City, Xi Shun was given this famous title. He stands **7 ft. 8.95 in.** (2 m, 35.1 cm), just slightly ahead of the previous record-holder (see box). Doctors don't know just why Xi Shun shot up so much; his parents are normal-sized. But he's healthy and enjoys his new fame.

Long Tall Sandy

Sandy Allen was a normal-sized baby, but she quickly started growing. She's been better than normal ever since. When she was last measured, she was **7 ft. 7.25 in.** (2 m, 31.7 cm) tall, making her **WORLD'S TALLEST LIVING WOMAN**. Not surprisingly, she weighs more than 300 lbs. (136 kg). Her shoe size? A hard-to-find size 22!

2:1 A pair of average-sized 7-year-olds would be as tall as Sandy.

Sandy wrote an autobiography in 2001 called "Cast a Giant Shadow."

WHAT DO U.S. GOVERNMENT FIGURES SAY IS THE AVERAGE HEIGHT FOR AN AMERICAN WOMAN: 5 FEET, 5 FEET 4 INCHES, OR 5 FEET 9 INCHES?

The average American woman is 5 feet, 4 inches tall.

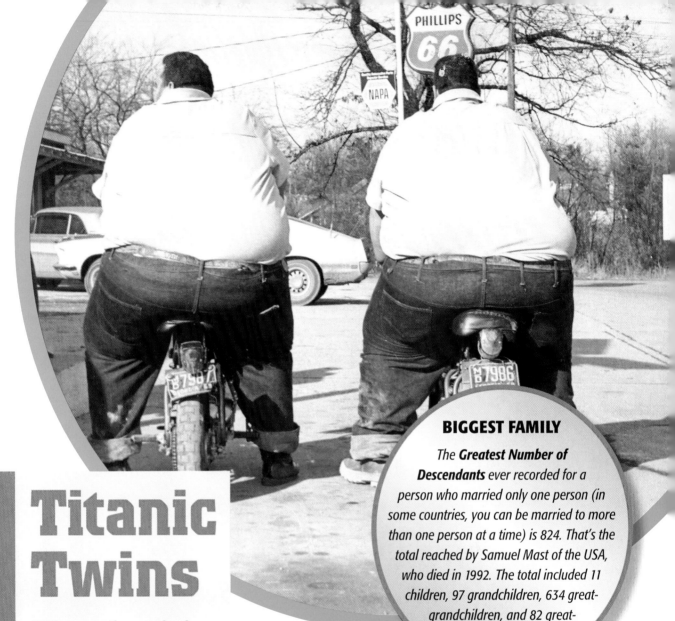

Titanic Twins

There are thousands of candidates, but this is our pick for perhaps the most famous photo from the Guinness World Records book. Shown on their normal-sized motorcycles near their home in Texas are the **WORLD'S HEAVIEST TWINS**. Billy Leon and Benny Lloyd McCrary (also known as McGuire) were just impressively huge—and a matched set! Billy weighed **743 lbs.** (337 kg), while his "little" brother Benny was "only" **723 lbs.** (328 kg) in 1978.

BIGGEST FAMILY

The **Greatest Number of Descendants** ever recorded for a person who married only one person (in some countries, you can be married to more than one person at a time) is 824. That's the total reached by Samuel Mast of the USA, who died in 1992. The total included 11 children, 97 grandchildren, 634 great-grandchildren, and 82 great-great-grandchildren.

11:1 Get 11 of your average-sized pals together and you'll be the same weight together as one twin!

OUT OF HOW MANY BIRTHS ARE IDENTICAL TWINS BORN: ONE IN 100, 250, OR 1,000?

Fraternal twins occur at different rates around the world, but identical twins occur about every 250 births worldwide.

A Long Way Around

Judging who is the heaviest living person is tricky stuff. Guinness World Records is aware of living people who weigh more than 1,120 lbs. (508 kg), but does not have a record-holder with a fully-verified weight.

However, some very extreme bodies have been measured and earned a place here.

The photo below shows Walter Hudson (1944–1991). His peak weight was **1,197 lbs.** (552 kg), but he is included here for having the WORLD'S LARGEST WAIST. It was measured at **119 in.** (3.02 m).

Mr. Hudson was confined to his room for many years, but later in his life, friends and celebrities helped him lose enough weight to get out and about.

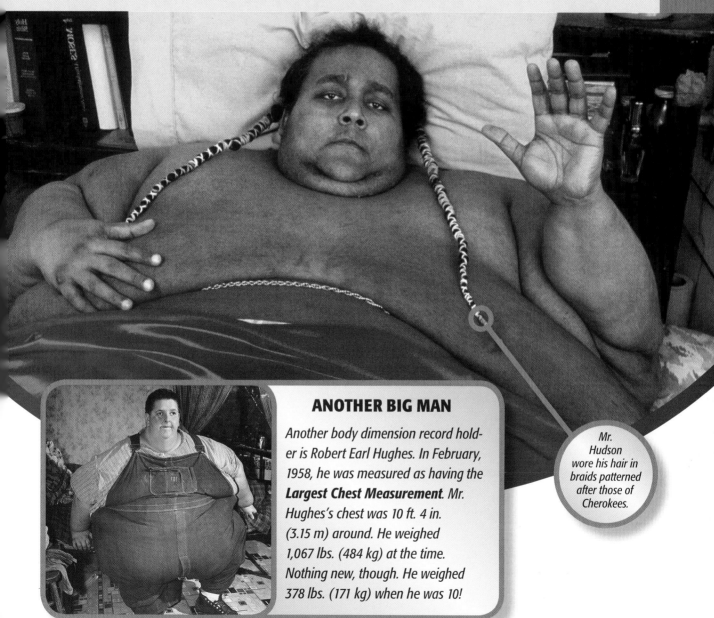

Mr. Hudson wore his hair in braids patterned after those of Cherokees.

ANOTHER BIG MAN

Another body dimension record holder is Robert Earl Hughes. In February, 1958, he was measured as having the **Largest Chest Measurement**. *Mr. Hughes's chest was 10 ft. 4 in. (3.15 m) around. He weighed 1,067 lbs. (484 kg) at the time. Nothing new, though. He weighed 378 lbs. (171 kg) when he was 10!*

ABOUT HOW MANY CALORIES DO MOST HEALTH AUTHORITIES SAY AN ADULT SHOULD EAT EVERY DAY?

Though there are some variations based on size and age, about 2,000 calories is a suggested average daily amount.

Your Big Body

HEAVIEST BRAIN:
5 POUNDS, 1.1 OZ (2.3 KG)

Measured in 1992 by Dr. George T. Mandybur of Cincinnati, Ohio. Note: It wasn't his brain!

LARGEST ARTERY:
AORTA

Arteries carry blood rich with oxygen out from the heart to the rest of the body. The 1.18 in. (3 cm) aorta is the body's **Largest Artery.**

STRONGEST JOINT:
HIP JOINT

Helping support your upper body and helping control your legs, hip joints are the **Strongest Joints** in the body. Joints are where bones come together, usually to help you to bend; other joints include your knees, elbows, and wrists.

LARGEST INTERNAL ORGAN:
LIVER

You pretty much can't live without your liver. It helps clean your blood, gets rid of bodily wastes, and does dozens of other important jobs. And it's the biggest thing inside your body, equaling 1/36th of total body weight.

LARGEST MUSCLE:
GLUTEUS MAXIMUS

That's right, the muscle in your butt is the biggest one in the human body. Another fun fact is that muscles make up 35-40 percent of our body's weight.

LARGEST VEIN: INFERIOR VENA CAVA

*Veins carry blood back from the body to the heart, where the blood gets pumped full of oxygen. The inferior vena cava is the **Largest Vein**, coming up from your legs into your heart.*

COMMONEST BLOOD GROUP: O

*Blood is "typed" into four categories, based on certain counts of types of cells: O, A, B, AB. The **Commonest Blood Group** in the world is O, in 46 percent of the world's bodies.*

LONGEST BONE: FEMUR

The thigh bone's connected to the hip bone, the hip bone's connected to the pelvis, and on and on . . . The thigh bone, or femur, is your body's longest bone, usually about 27.5 percent of a person's stature.

LARGEST SESAMOID BONE: KNEECAP

Sesamoid bones are the small, rounded ones usually found around fingers and toes. But the knee cap, or patella, dwarfs them all to take this title.

HOW MANY BONES ARE IN THE HUMAN BODY: 110, 206, OR 404?

From the top of your skull to the tip of your toes, you have 206 bones in your body.

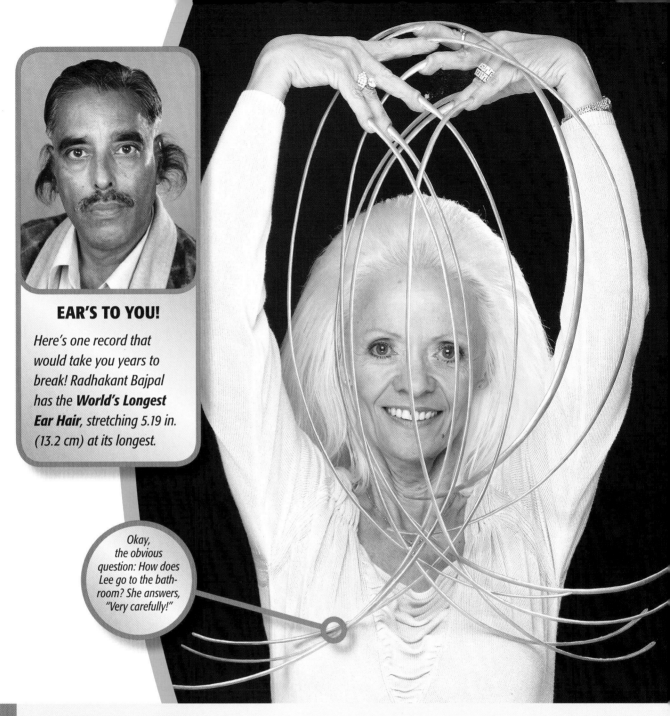

Okay, the obvious question: How does Lee go to the bathroom? She answers, "Very carefully!"

She Nailed It!

No, those are not fake fingernails. Those are real, and Lee Redmond proudly holds them up as the WORLD'S LONGEST FINGERNAILS.

Lee hasn't cut her nails since 1979, and they are now a total length of **24 ft. 7.8 in.** (7.51 m). Not surprisingly, she can't put clothes on over her head, so she pulls shirts and sweaters up over her legs and waist! When she sleeps, they just hang off the side of the bed. Lee eats a lot of protein to help her nails grow. She soaks them in warm olive oil if they get dry or brittle.

TRUE OR FALSE: FINGERNAILS KEEP GROWING AFTER A PERSON DIES.

False: It just looks like they grow, because the skin around them shrinks.

A Human Pincushion

If you want to get an earring someday, don't let your mom see this picture. She might just think you'll try to copy it! This multi-metaled person is Elaine Davidson, the **WORLD'S MOST PIERCED PERSON**.

Elaine, who lives in Great Britain, first got a piercing back in 1979 . . . and just couldn't stop! As of October 13, 2004, she had somehow found enough empty space to have **2,520 piercings**, including 192 on her face alone! She has pierced just about every other place on her body.

And yes, that is a hole in her tongue . . . just another one of her piercings. Ouch!

THE NOSE KNOWS

*Everyone has one of these, but there's only one **Longest Nose on a Living Person**. Though not pictured here, it can be found on the face of Mehmet Ozyurek of Turkey. His prodigious proboscis was measured on January 31, 2001, as being 3.46 in. (8.8 cm) from the bridge to the tip. A circus performer named Thomas Wedders, who lived in England in the 1770s, supposedly had the **Longest Nose Ever** nose that was 7.5 in. (19 cm) long!*

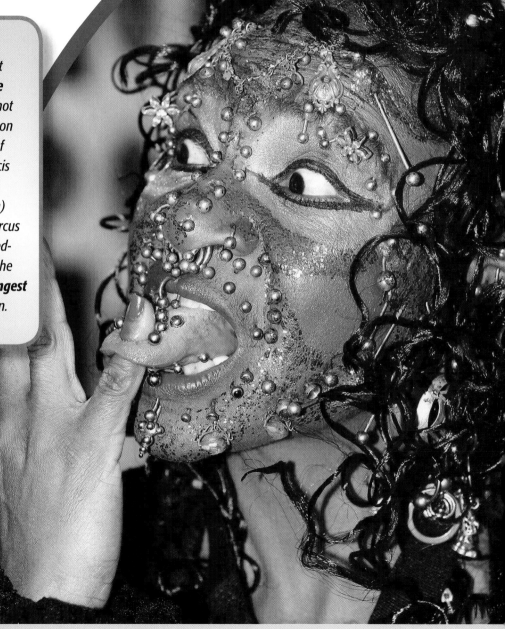

TRUE OR FALSE: BODY PIERCING IS A FAIRLY NEW TREND IN WORLD CULTURE.

False: Body piercing is an ancient art practiced in cultures around the world for centuries.

Seven's the Record

Talk about having in instant family. On November 19, 1997, Bobbie McCaughey welcomed a whole nursery full of kids into the world—and all of them were her kids! Bobbie was the mom of seven kids—the **MOST CHILDREN AT A SINGLE BIRTH TO SURVIVE.**

The McCaughey septuplets became world-famous after they survived the tough part of being born. They weighed from **2 lbs., 5 oz.** to **3 lbs. 4 oz.** (1,048 g to 1,474 g) at birth. Amazingly, another set of surviving septuplets was born in 1998 in Saudi Arabia.

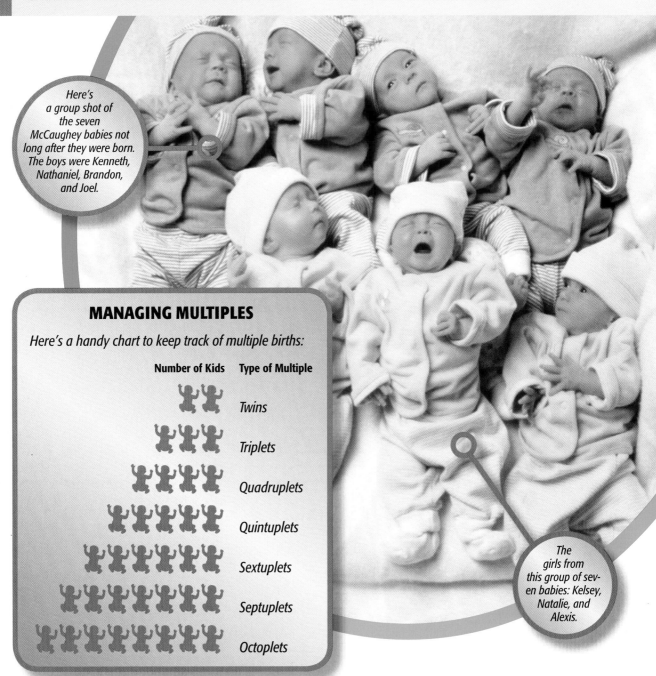

Here's a group shot of the seven McCaughey babies not long after they were born. The boys were Kenneth, Nathaniel, Brandon, and Joel.

The girls from this group of seven babies: Kelsey, Natalie, and Alexis.

MANAGING MULTIPLES

Here's a handy chart to keep track of multiple births:

Number of Kids	Type of Multiple
👶👶	Twins
👶👶👶	Triplets
👶👶👶👶	Quadruplets
👶👶👶👶👶	Quintuplets
👶👶👶👶👶👶	Sextuplets
👶👶👶👶👶👶👶	Septuplets
👶👶👶👶👶👶👶👶	Octoplets

U.S. PRESIDENT GEORGE W. BUSH AND HIS WIFE LAURA HAVE TWIN DAUGHTERS: WHAT ARE THEIR NAMES?

The "First Twins," as they are sometimes called, are Jenna and Barbara Bush.

Slam Dunk!

Even though this happened on April 1, 2000, trust us—this is not an April Fools' joke! On that day, Michael "Wild Thing" Wilson soared higher than anyone else ever had to slam home the **WORLD'S HIGHEST SLAM DUNK**. After making a few dunks above 11 ft., he gathered all his energy and his 6-ft. 6-in. (1.95 m) frame, and soared to the new record—**12 ft.** (3.65 m). Michael plays for the famous Harlem Globetrotters traveling team. He sometimes tries to break his record during the 'Trotters' tours.

HEADS UP!

*Talk about using your head! On November 10, 2000, Eyal Horn made the **Furthest Basketball Shot with the Head!** He shot the ball with just his head and made it from 25 ft. (7.62 m)!*

MR. FREE THROW

*The record for **Most Successful Free Throws in One Hour** is 1,076 (out of 1,266 tries) by Michael Campbell at Rutgers University on April 3, 2005.*

WHAT FAMOUS BASKETBALL BROADCASTER IS CREDITED WITH INVENTING THE TERM "SLAM DUNK"?

The play has been part of basketball since George Mikan first did it in the 1950s, but it was the Lakers' announcer Chick Hearn who coined the term.

This Guy Is Just Big

There are no shrimps in the sumo ring, but to be in sumo, you've got to eat a lot of shrimp . . . and pretty much everything else you can reach. Sumo is an ancient Japanese form of wrestling that pits two behemoths against each other, Hawaiian-born Chad Rowan, known as Akebono, became the first foreign-born yokozuna in January, 1993, the highest ranking in the sport. He also became the **WORLD'S LARGEST YOKOZUNA SUMO WRESTLER**. Chad weighed **501 lbs.** (227 kg) and stood a towering **6 ft. 8 in.** (2.04 m).

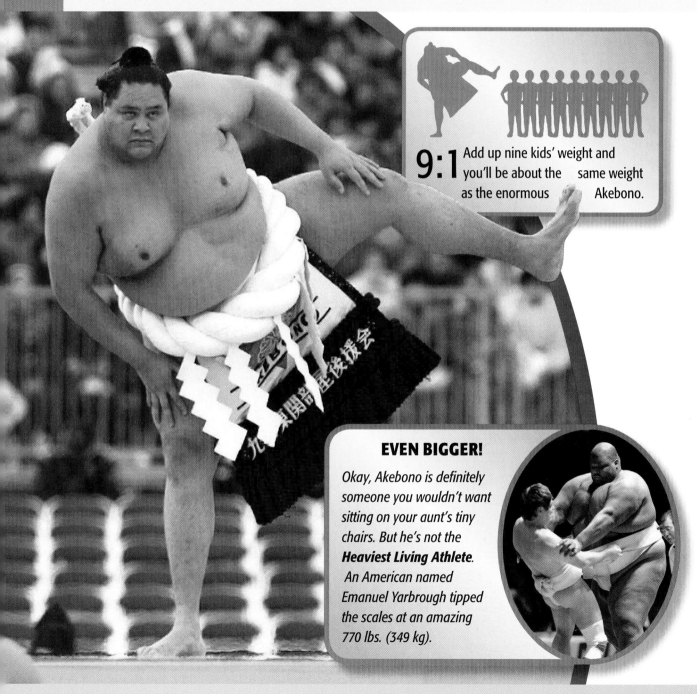

9:1 Add up nine kids' weight and you'll be about the same weight as the enormous Akebono.

EVEN BIGGER!

Okay, Akebono is definitely someone you wouldn't want sitting on your aunt's tiny chairs. But he's not the **Heaviest Living Athlete**. *An American named Emanuel Yarbrough tipped the scales at an amazing 770 lbs. (349 kg).*

HOW DOES A SUMO WRESTLING MATCH END?

A match ends when one wrestler is forced out of the fighting ring or if he touches the ground with anything other than the bottom of his feet.

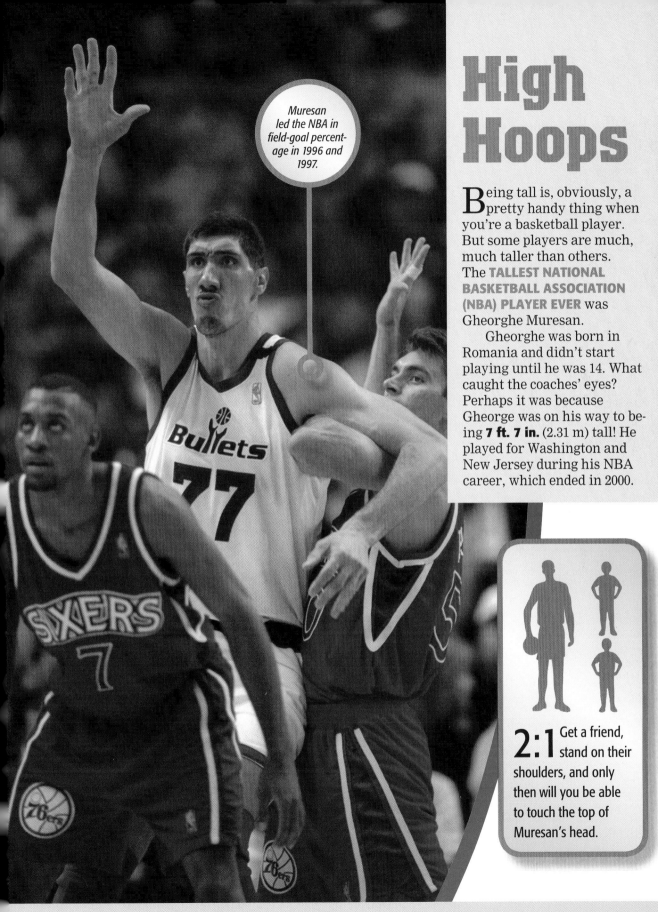

Muresan led the NBA in field-goal percentage in 1996 and 1997.

High Hoops

Being tall is, obviously, a pretty handy thing when you're a basketball player. But some players are much, much taller than others. The **TALLEST NATIONAL BASKETBALL ASSOCIATION (NBA) PLAYER EVER** was Gheorghe Muresan.

Gheorghe was born in Romania and didn't start playing until he was 14. What caught the coaches' eyes? Perhaps it was because Gheorge was on his way to being **7 ft. 7 in.** (2.31 m) tall! He played for Washington and New Jersey during his NBA career, which ended in 2000.

2:1 Get a friend, stand on their shoulders, and only then will you be able to touch the top of Muresan's head.

WHAT BASKETBALL SCORING RECORD DOES THE GREAT MICHAEL JORDAN HOLD?

The amazing Jordan has the highest Scoring Average in an NBA Career. He averaged 30.1 points per year.

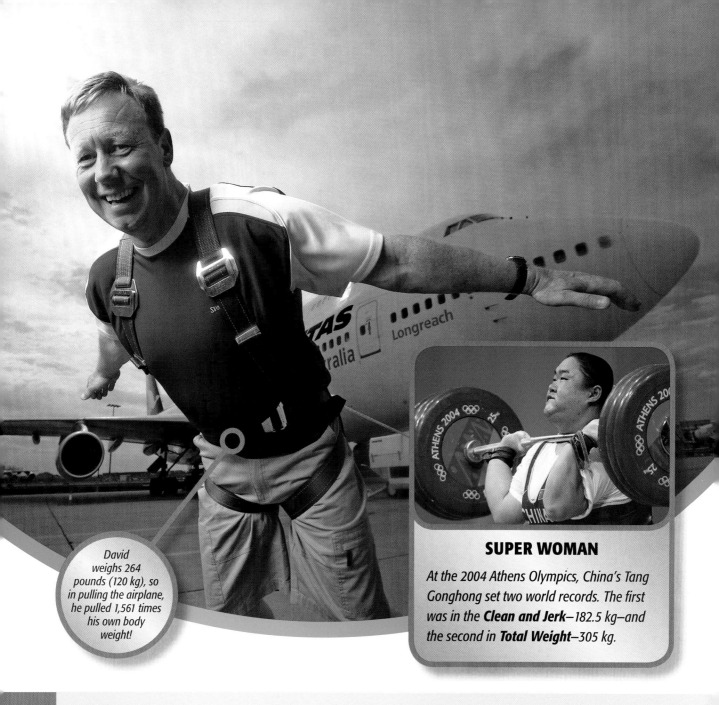

David weighs 264 pounds (120 kg), so in pulling the airplane, he pulled 1,561 times his own body weight!

SUPER WOMAN

At the 2004 Athens Olympics, China's Tang Gonghong set two world records. The first was in the **Clean and Jerk**–182.5 kg–and the second in **Total Weight**–305 kg.

Power Pull

Normally, tractors or trucks pull giant airplanes into position. Well, if those machines ever break, here's their replacement. In 1997, David Huxley of Australia pulled a Boeing 747-400—weighing an incredible **412,264 lbs.** (186,999 kg)—a distance of **298 ft. 6 in.** (91 m).

That made the plane the **HEAVIEST AIRCRAFT PULLED BY AN INDIVIDUAL**, and made David a record holder!

David also set the record for **HEAVIEST BOAT PULLED** on November 19, 1998. The boat, filled with cars and people, weighed **1,217,847 lbs.** (1,005,998 kg).

WHAT STRENGTH-ORIENTED SPORT (AT WHICH DAVID HUXLEY WOULD EXCEL!) WAS ONCE AN OLYMPIC SPORT?

The first several modern Olympic Games featured a team tug-of-war contest.

Small but Powerful

Please tell us that you won't try this at home . . . but then again, why would you? On September 11, 2004, Thomas Blackthorne stuck out his tongue and set a new record. No, not for longest tongue (see page 27 for that!). Mr. Blackthorne attached a special clip to his tongue, spread his feet, and produced the **HEAVIEST WEIGHT LIFTED WITH TONGUE**. Millions watched as he did it, too, since he was live on the set of *Guinness World Records: 50 Years, 50 Records*. His record lift? An amazing **24 lbs. 3 oz.** (11.025 kg).

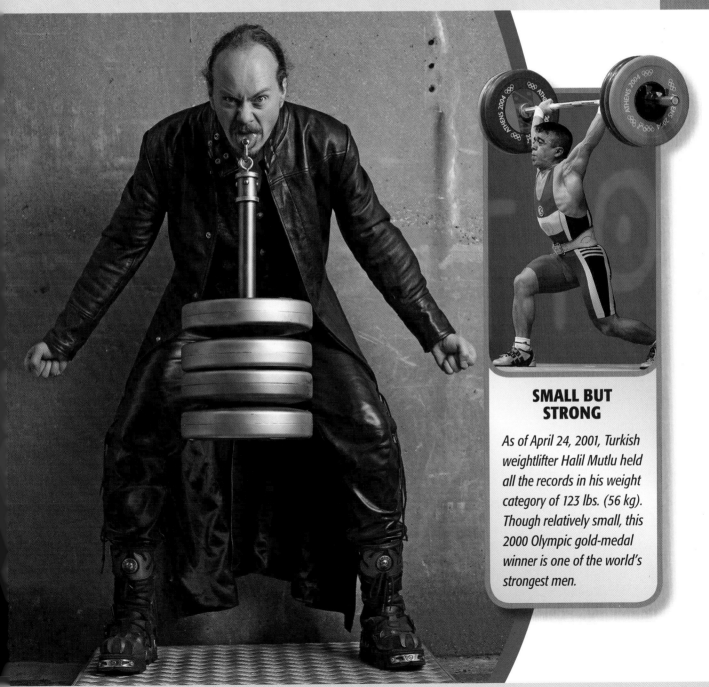

SMALL BUT STRONG

As of April 24, 2001, Turkish weightlifter Halil Mutlu held all the records in his weight category of 123 lbs. (56 kg). Though relatively small, this 2000 Olympic gold-medal winner is one of the world's strongest men.

WHICH OF THE FOLLOWING IS NOT A TYPE OF WEIGHTLIFTING MOVE: CLEAN AND JERK, WHIP-UP, SNATCH?

We're not sure where we came up with whip-up, but it has nothing to do with weightlifting!

Say Aaaah!

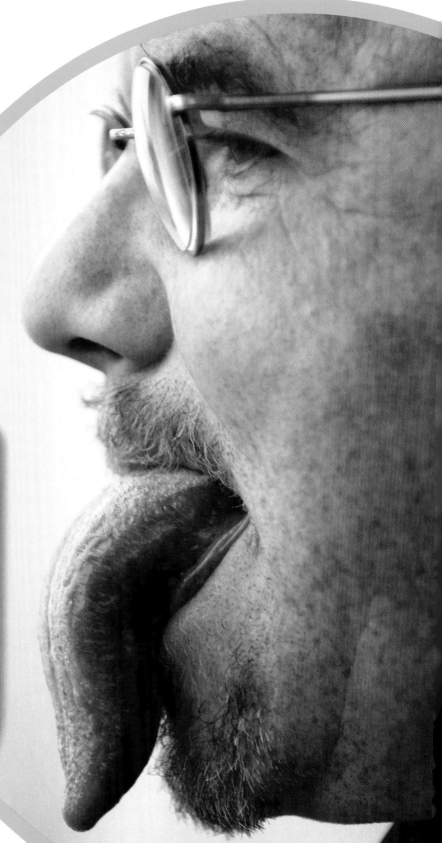

Stephen Taylor is famous, but for something that you probably wouldn't guess . . . until he opens his mouth. That's because Stephen is the owner and user of **WORLD'S LONGEST TONGUE**. It measures **3.7 in.** (9.4 cm) from the tip to the lip.

We're just hoping that he doesn't have to say the "Peter Piper picked a peck of pickled peppers" rhyme. Stephen's tongue would take forever to untwist!

EAR-RIFFIC!

*Some cultures believe that long earlobes represent wisdom. Some southeast Asian tribes take this to extremes, using weights to create the **World's Longest Earlobes**.*

ABOUT HOW MANY TASTE BUDS ARE ON THE AVERAGE TONGUE: 100, 1,000, OR 9,000?

About 9,000 tiny taste buds cover the surface of the tongue, helping you enjoy all those vegetables, right?

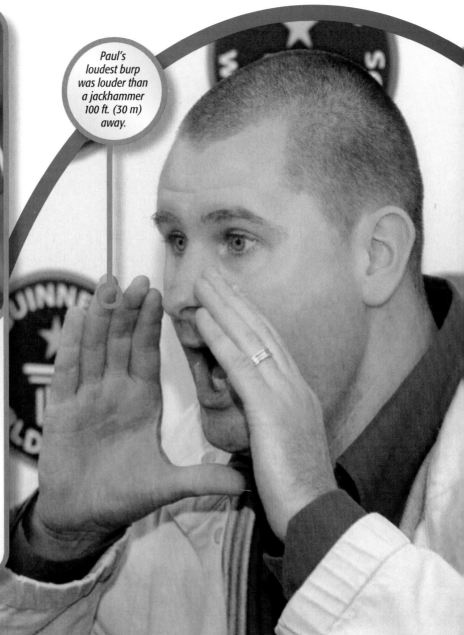

Paul's loudest burp was louder than a jackhammer 100 ft. (30 m) away.

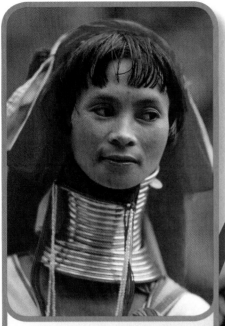

GIRAFFE PEOPLE?

*Well, no, of course not, but the women of the Padaung and Kareni tribes of Myanmar (Burma) see long necks as beauty marks. They wrap metal coils to slowly stretch their necks. The **Longest Neck** ever measured was 15.75 in. (40 cm). If the coils are removed, the necks are too weak to hold up their heads!*

A Big "Excuse Me!"

Finally, a record we can all take a shot at. Everyone burps, after all, it's a natural thing. However, some lucky people have a talent for making really loud burps. Paul Hunn of Great Britain stands lips, tongue, and throat above the rest, however, as the holder of the WORLD'S LOUDEST BURP.

In 2004, during a visit to the offices of Guinness World Records, Paul ripped off a beauty, tipping the scales on the official noise-measuring device at **104.9 decibels**.

How loud is that? A power lawnmower is 90 decibels. A jet taking off is about 105 and a car horn is 110. Paul is nearly a human jet!

PEOPLE

WHEN YOU BURP, WHAT IS ESCAPING FROM YOUR BODY?

Gas, such as carbon dioxide, that you swallow with your food and drink.

STAR WARS WINNER

Between Stars Wars and Indiana Jones and a pile of other big hits, actor Harrison Ford has starred in some of the most successful movies of all time. In fact, Ford's 27 movies have earned (through early 2005) a total of $3,369,662,963 at the box office, the **Highest Movie Box Office Gross for an Actor**. Julia Roberts is the top actress at about $2.9 billion.

ONE CROWDED WAVE!

This is not the exact moment, but it may have looked a lot like this on December 1, 2002, at Manly Beach, Sydney, Australia, when 38 people climbed on their surfboards and set the record for **Most Surfers Riding the Same Wave**!

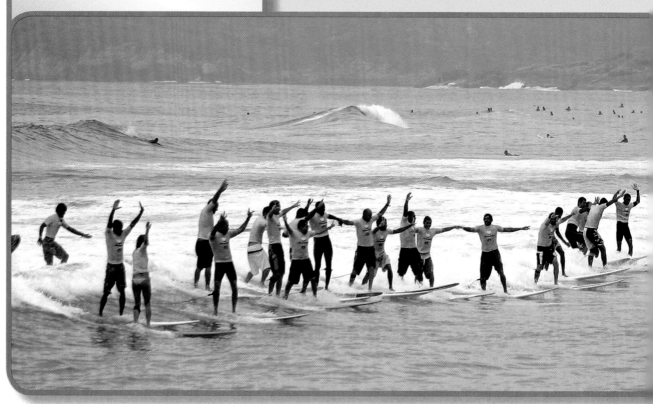

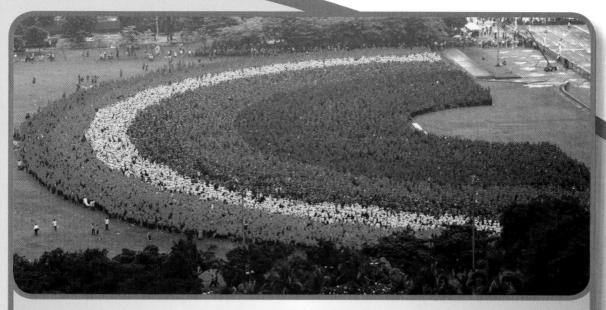

ALL SEVEN COLORS

*Wearing color-coordinated T-shirts and baseball caps, 30,365 students, faculty, and staff of the Poly-technic University of the Philippines created this colorful, record-setting gathering in 2004. Assembling in gigantic Rizal Park, they formed the **World's Largest Human Rainbow**!*

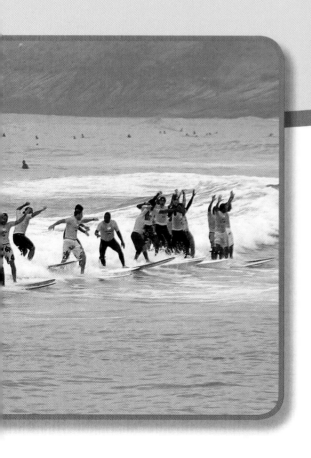

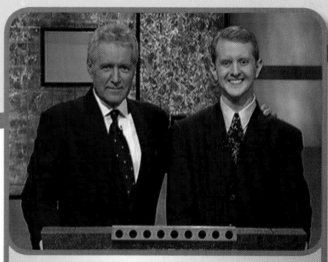

RECORD SETTERS FOR $500, PLEASE

*The answer is . . . $2,520,700. And the question is: How much did Ken Jennings take home during his amazing 75-episode run on Jeopardy!, from June 2 to November 30, 2004 to earn the **Largest Cash Prize on a TV Game Show**? Jennings knocked off 149 challengers and answered more than 2,000 questions!*

Animals

Lions and tigers and bears . . . and tarsiers and goliath beetles and ostriches . . . and more! In this chapter, take a walk on the wild side and learn more about the biggest, tallest, largest, most amazing oversized members of the animal kingdom.

WHALE OF A TAIL

You can tell by the size of this blue whale's tail compared to the researchers in the boat that this is one gigantic animal (page 32).

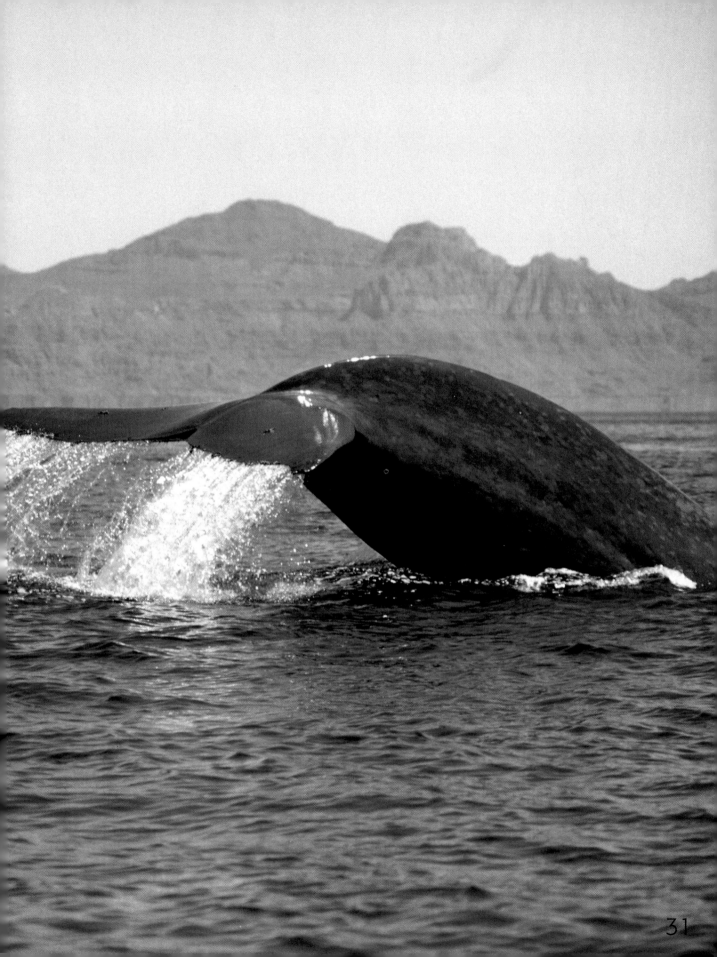

Biggest Ever!

Millions of species of animals have walked, flown, crawled, slithered, or paddled on Earth. But only one gets to hold the title of **WORLD'S LARGEST MAMMAL.** Gliding gracefully through the world's ocean, the blue whale is larger than any animal—except some dinosaurs. The average length of a blue whale is **80 ft.** (24 m) and it can weigh **352,000 lbs.** (159,600 kg). One specimen in Antarctica weighed in at **344,000 lbs.** (156,038 kg), making it the **HEAVIEST MAMMAL EVER RECORDED**! Blue whales are gentle giants, however, whose only enemy is probably pollution. Though their numbers are threatened worldwide, many people are working to help these enormous creatures.

The blowhole for the blue whale is located on its back near the head.

2:1 The largest blue whales can reach 80 feet; that would equal two school buses!

BIG BUT SAFE

Blue whales may be enormous, but they're not dangerous to humans. They eat only krill, a type of shrimp. A lot of krill! They can eat 7,000 lbs. (3,175 kg) of krill a day.

Blue whales live in all the world's oceans, but there may only be about 2,000

WORLD'S SMARTEST ANIMAL?

*Well, not really, but while you might be better at math or have all the state capitals memorized, your big brain is tiny compared to the **Largest Animal Brain**. Weighing in at nearly 19 lbs. 13 oz. (9 kg), the brain of the sperm whale is almost seven times as large as yours. It is almost twice as big as an elephant's brain, too!*

IN "MOBY DICK," THE FAMOUS NOVEL ABOUT A WHALE, WHAT COLOR WAS THE WHALE?

Captain Ahab was chasing Moby Dick, a whale that was all white.

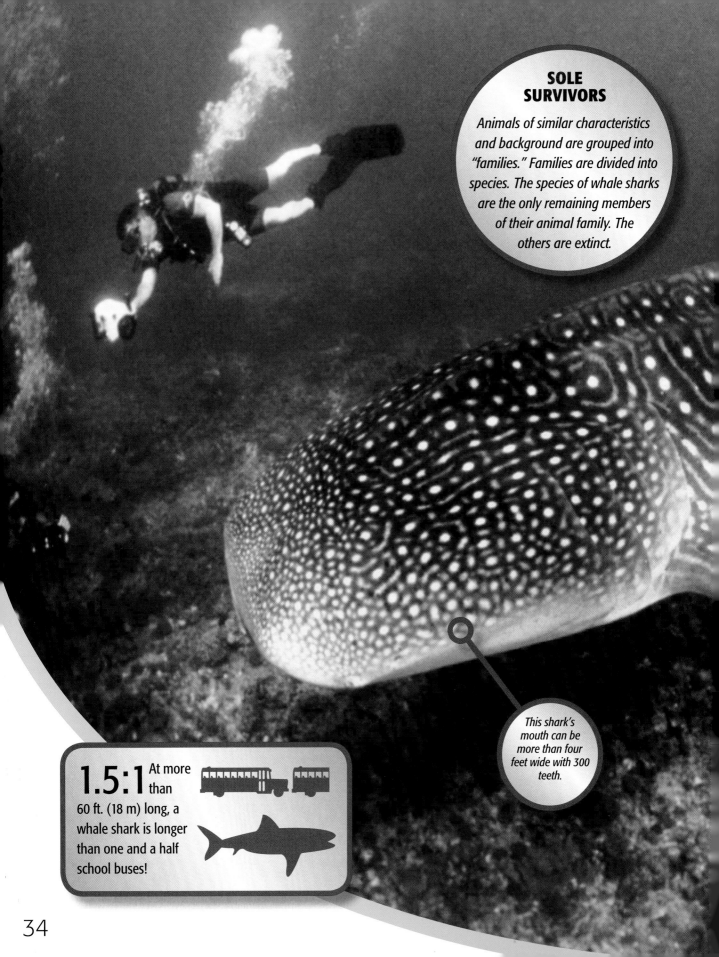

Animals of similar characteristics and background are grouped into "families." Families are divided into species. The species of whale sharks are the only remaining members of their animal family. The others are extinct.

This shark's mouth can be more than four feet wide with 300 teeth.

1.5:1 At more than 60 ft. (18 m) long, a whale shark is longer than one and a half school buses!

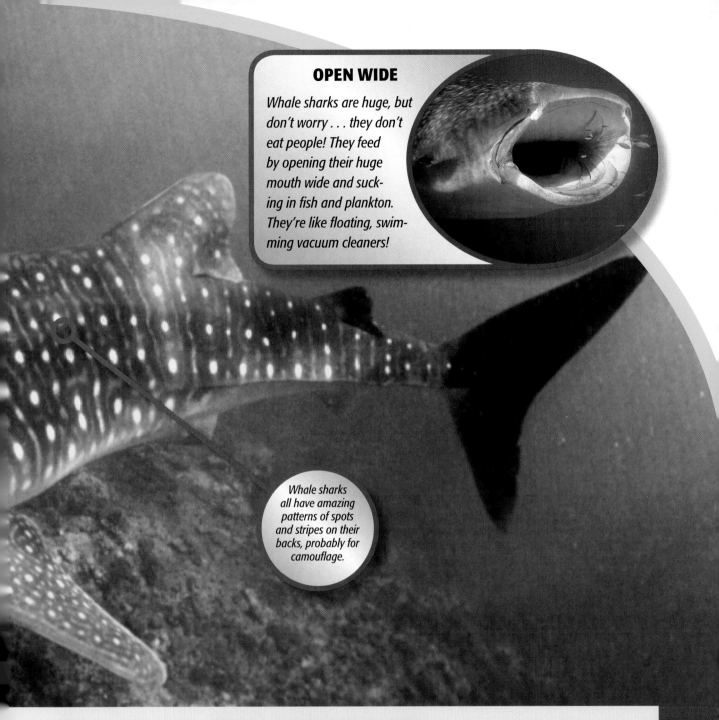

Whale sharks all have amazing patterns of spots and stripes on their backs, probably for camouflage.

Gone Fishin'!

If you saw a whale shark swimming your way, should you swim for cover? Well, only if you're a plankton or a tiny fish. The whale shark, or basking shark, might be the **WORLD'S LARGEST FISH**, but it's pretty much harmless to humans. Still . . . man, is it big!

Whale sharks can grow as long at **41 ft. 6 in.** (12.6 m) while weighing **33,000 to 46,200 lbs.** (15,000 to 21,000 kg). Measuring **23 ft.** (7 m) around, they live in warm oceans (Atlantic, Pacific, and Indian), usually not far from the Equator.

ANIMALS

HERE'S AN EASY ONE (WE THINK): IS PHYTOPLANKTON, THE WHALE SHARK'S MAIN FOOD, ANIMAL OR PLANT?

Plankton (well, phytoplankton) is a type of plant. There is also zooplankton, which are tiny animals.

Trunk Talk

They say that an "elephant never forgets." Well, now you have a fact that you'll never forget. The male African elephant is the **WORLD'S LARGEST LAND MAMMAL**. They can weigh between **8,800 and 15,400 lbs.** (3,990 to 6,985 kg) and stand **10 to 12 ft.** (3 to 3.7 m) at the shoulder. One weighed in 1974 tipped the scales at **26,984 lbs.** (12,239 kg).

Animal trivia fans will note that the Indian elephant is typically smaller than the African elephant.

3:1 You have to climb on the shoulders of two of your friends to be as tall as an elephant.

LIFE IN THE TREES

In the Malay language, "organu-tan" means "man of the forest." Orangutans aren't men, of course, but they are the **Largest Tree-Dwelling Mammal**. They live in the rainforests of Borneo.

The ivory tusks of elephants are sometimes sold as sculpture or jewelry. Sadly, this has terribly reduced the world elephant population. Many countries are working to stop this.

TRUE OR FALSE: ELEPHANTS MAKE UP THE MEMBERS OF THE LARGEST ANIMAL ORCHESTRA.

True! The record-holder is the 12-piece Thai Elephant Orchestra, founded in 2000 in Lampang, Thailand, to help promote elephant conservation.

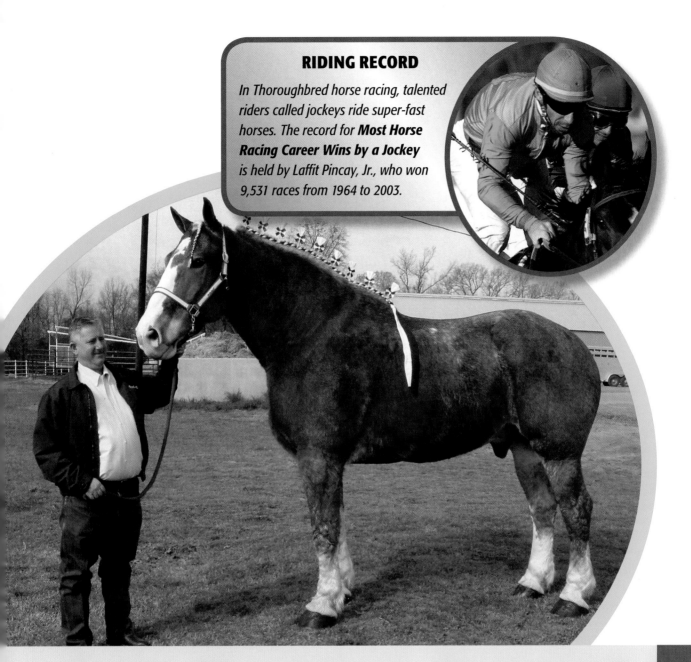

Just Horsing Around

If you like to ride horses and you want to ride the one pictured here—bring a ladder! Radar, a Belgian draft horse, is the **WORLD'S TALLEST HORSE.**

In 2004, Radar was measured at a horse show in Canada as being **79.5 in.** (202 cm) tall. That's more than six-and-a-half feet! Another way to measure Radar is by using "hands," a special way to measure the height of horses.

It comes from the time before feet and inches. A "hand" in this case, based on the width of a man's spread hand (thumb to pinky), is about 4 inches. So Radar is **19 hands, 3.5 in.** tall.

Belgian draft horses are from, naturally, Belgium. They were bred to help pull large carts or plows in the farms of that country. They remain popular among farmers.

ANIMALS

TRUE OR FALSE: A PONY IS A BABY HORSE.

False! A pony is a full-grown type of horse; they're just smaller than most other types. A foal is a baby horse.

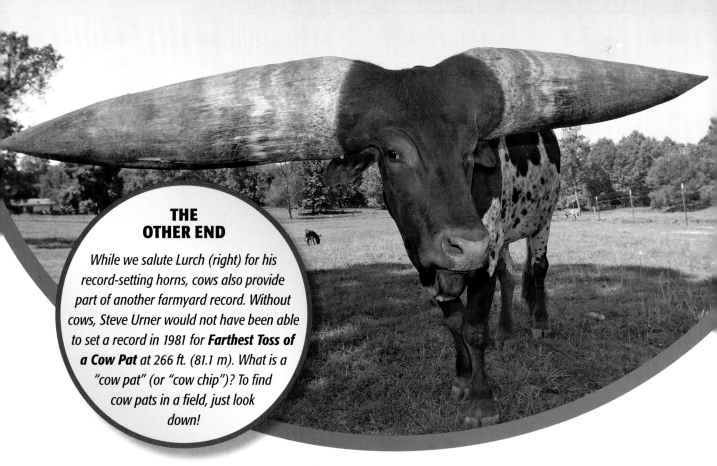

While we salute Lurch (right) for his record-setting horns, cows also provide part of another farmyard record. Without cows, Steve Urner would not have been able to set a record in 1981 for **Farthest Toss of a Cow Pat** at 266 ft. (81.1 m). What is a "cow pat" (or "cow chip")? To find cow pats in a field, just look down!

Cow's This?

When we see this picture of Lurch, a watusi steer owned by Janice Wolf of Arkansas, all we can think is: I hope they have pretty wide barn doors on Janice's farm! That's because Lurch boasts the **WORLD'S LARGEST HORN CIRCUMFERENCE**. Each horn span is more than **7 ft.** (2.1 m) long and measures **37.5 in.** (95.25 cm) around.

Lurch has company on the farm. Janice runs Rocky Ridge Refuge, a shelter for rescued animals.

ANIMALS

RECORD-SETTING COWBOY

*Seven-time all-around champ Ty Murray is a big star in the rough-and-tumble sport of professional rodeo. A bull-riding specialist, Ty won $2,931,277 from 1989 to 2002, giving him the record for **Highest Career Rodeo Winnings**.*

A RODEO QUESTION: HOW LONG DO BULL-RIDERS HAVE TO STAY ON THE BULL TO SCORE POINTS: 3, 8, OR 20 SECONDS?

If they stay on for 8 seconds, they can get full points for the ride . . . and ice for their bruises!

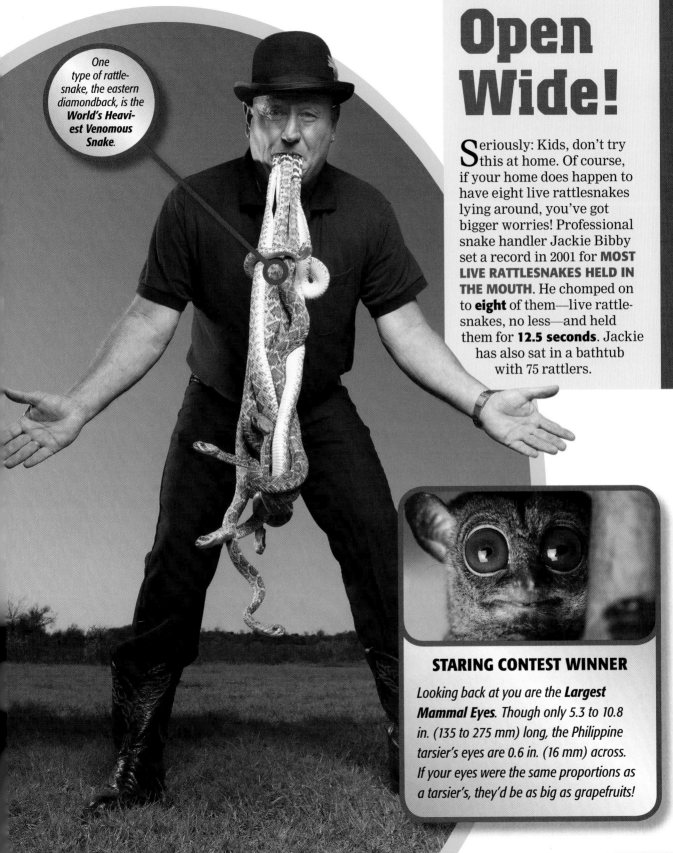

One type of rattle-snake, the eastern diamondback, is the **World's Heaviest Venomous Snake.**

Open Wide!

Seriously: Kids, don't try this at home. Of course, if your home does happen to have eight live rattlesnakes lying around, you've got bigger worries! Professional snake handler Jackie Bibby set a record in 2001 for **MOST LIVE RATTLESNAKES HELD IN THE MOUTH.** He chomped on to **eight** of them—live rattle-snakes, no less—and held them for **12.5 seconds.** Jackie has also sat in a bathtub with 75 rattlers.

STARING CONTEST WINNER

*Looking back at you are the **Largest Mammal Eyes.** Though only 5.3 to 10.8 in. (135 to 275 mm) long, the Philippine tarsier's eyes are 0.6 in. (16 mm) across. If your eyes were the same proportions as a tarsier's, they'd be as big as grapefruits!*

WHAT IS THE <u>LONGEST SPECIES OF SNAKE</u> IN THE WORLD?

The reticulated python, which lives in Southeast Asia, can grow to more than 20 feet (6.25 m). The longest ever reached 32 ft. 9.5 in. (10 m).

39

One Big Spider, Man!

Imagine this scary sight: You're sitting down to dinner, all ready to fill up your empty plate, when a spider crawls across the empty white surface. Now imagine this scarier sight: A spider big enough to *cover the entire plate*! If the spider pictured here wandered onto your table, that's what could happen, because this is the goliath bird-eating spider, the **WORLD'S LARGEST SPIDER**. Don't worry, though, they live in rainforests of northern South America!

The largest one ever found had a leg span of **11 in.** (28 cm) across. As if looking scary isn't enough, these spiders can also hiss when threatened and shoot out tiny hairs that can cause pain to humans if inhaled.

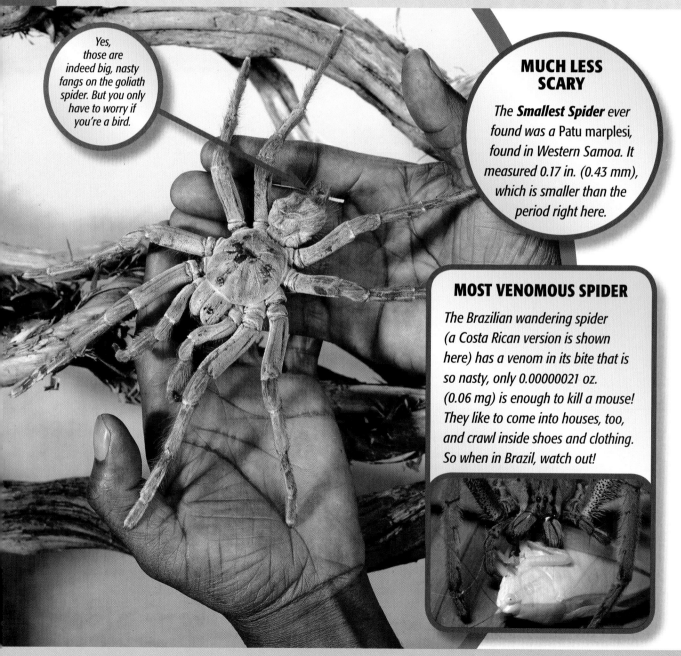

Yes, those are indeed big, nasty fangs on the goliath spider. But you only have to worry if you're a bird.

MUCH LESS SCARY

The **Smallest Spider** ever found was a Patu marplesi, found in Western Samoa. It measured 0.17 in. (0.43 mm), which is smaller than the period right here.

MOST VENOMOUS SPIDER

The Brazilian wandering spider (a Costa Rican version is shown here) has a venom in its bite that is so nasty, only 0.00000021 oz. (0.06 mg) is enough to kill a mouse! They like to come into houses, too, and crawl inside shoes and clothing. So when in Brazil, watch out!

HERE'S ONE FOR COMIC-BOOK FANS: HOW DID SPIDER-MAN® GET HIS POWERS?

40

He was bitten on the hand by a radioactive spider!

ONE BIG BUG

The **Heaviest Insect** in the world is the goliath beetle, which lives in Africa. Not only can one be as big across as a grown man's palm, they weigh 2.5 to 3.5 oz. (70 to 100 g), or about as much as a regular deck of playing cards! They don't bite, however, and prefer to eat dung. Yuck!

2:1 Spread your hands with thumbs touching. That's about the size of an atlas moth.

Mighty Moth!

You've seen moths tons of times, their tiny fluttering wings dancing around near a light or flitting about on a flower petal. If you saw this moth flapping around your front porch, however, you'd probably run inside and hide. The **12 in.** (30 cm) wide atlas moth is the **WORLD'S LARGEST MOTH**.

Atlas moths live in southeast Asia, however, so you're probably safe. They're so big that people who see them mistake them for a bird! One sad note about this gentle giant: Atlas moths only live for about four days, existing solely on stored fat. Why such a rotten diet? They have no mouth!

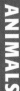

ANIMALS

CAN YOU NAME SOME DIFFERENCES BETWEEN MOTHS AND BUTTERFLIES?

Most moths are nocturnal, feeding at night, and have many shapes of antennae. Most butterflies feed during the day and have straight antennae.

Big Bird

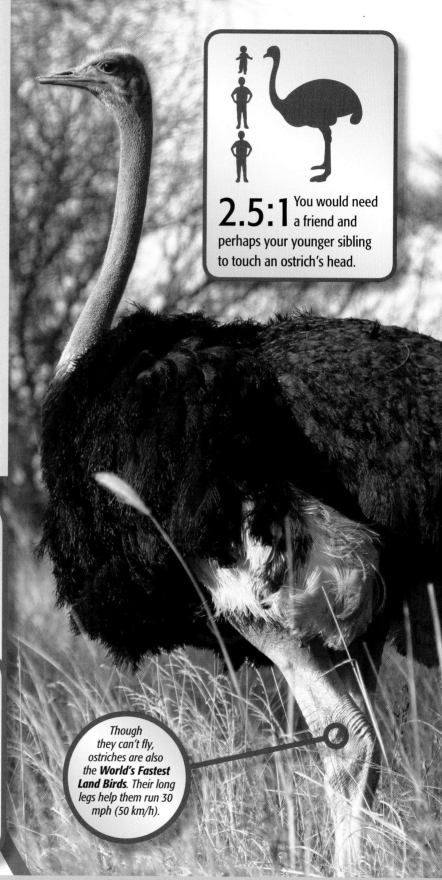

They can't fly, they are the only birds with just two toes, and they look pretty odd. But ostriches stand head and beak above the rest of the avian world as the **WORLD'S LARGEST BIRD**. Natives of Africa, ostriches can be as tall as **9 ft.** (2.75 m) and weigh as much as **345 lbs.** (156.5 kg). Their eggs (pictured below) are as large as two dozen chickens' eggs scrambled together. Their wings are too small to lift their huge bodies. Want to learn a cool new word? They are called ratite birds, which means "flightless."

2.5:1 You would need a friend and perhaps your younger sibling to touch an ostrich's head.

A REALLY BIG OMELET

*Ostriches, being the largest birds, naturally lay the **Largest Bird Eggs** in the world. Here a decorated ostrich egg is shown next to a painted chicken egg.*

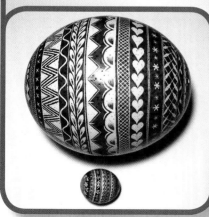

*Though they can't fly, ostriches are also the **World's Fastest Land Birds**. Their long legs help them run 30 mph (50 km/h).*

TRUE OR FALSE: OSTRICHES STICK THEIR HEADS IN THE GROUND TO HIDE.

False. They might, however, lay their heads near their nest to help protect their eggs from a predator.

Getting a Big Bill

There is a famous poem that includes the memorable lines, "A marvelous bird is the pelican/His mouth can hold more than his belican." That enormous capacity is thanks to the graceful shore bird owning the **WORLD'S LONGEST BILL**.

The longest pelican bills out there belong to the Australian pelican and can measure **13 to 18.5 in.** (34 to 47 cm) in length.

Pelicans in general use their enormous, expanding beaks to scoop up water they hope contains fish or other goodies. They strain the water out of the bills and the food then slips down their throat.

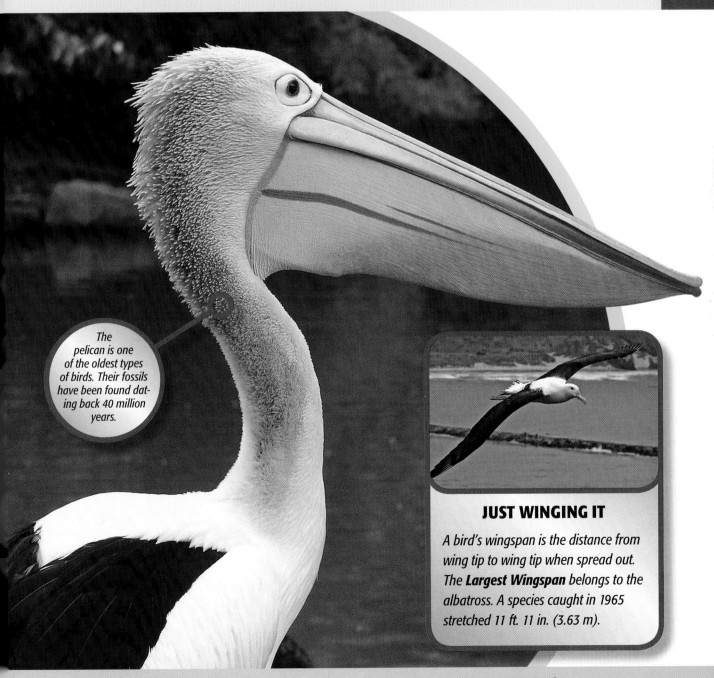

The pelican is one of the oldest types of birds. Their fossils have been found dating back 40 million years.

JUST WINGING IT

A bird's wingspan is the distance from wing tip to wing tip when spread out. The **Largest Wingspan** belongs to the albatross. A species caught in 1965 stretched 11 ft. 11 in. (3.63 m).

WHAT WAS THE MOST TALKATIVE BIRD: A PIGEON, A TOUCAN, OR A BUDGERIGAR?

A budgerigar named Puck, owned by Camille Jordan of Petaluma, California, knew an estimated 1,728 words before its death in 1994.

Giant Dino!

How big were the enormous dinosaurs known as sauropods? They were so big that all we could show you of one is this leg bone! No, just kidding, this is just to show how big they are compared to a regular-sized person . . . and this is just an upper leg bone! Sauropods as a group were the **WORLD'S LARGEST-EVER LAND ANIMALS**. Pleasant plant-eaters, sauropods had long necks, long tails, and enormous middles. Some types of sauropods were **131 ft.** (40 m) long and weighed as much as **220,000 lbs.** (99.792 kg). Which was the biggest type? The search goes on, as new fossils are discovered every year.

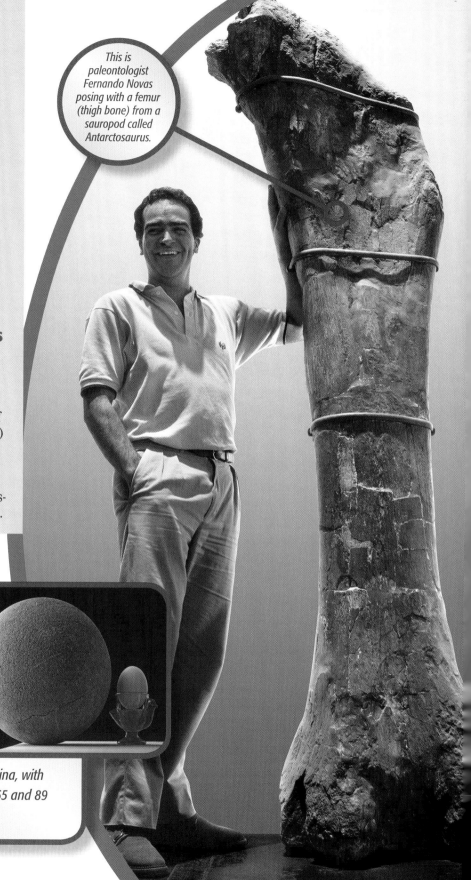

This is paleontologist Fernando Novas posing with a femur (thigh bone) from a sauropod called Antarctosaurus.

EGGS-CELLENT

On the left is a dinosaur egg. On the right, a chicken egg. So, no matter which came first, the chicken or the egg, the dinosaur would have eaten both. The **Largest Dinosaur Egg Collection** is in China, with more than 10,000 eggs between 65 and 89 million years old.

HOW DID DINOSAURS GET THEIR NAME?
The British scientist Sir Richard Owen coined the term in 1842; it means "terrible lizard."

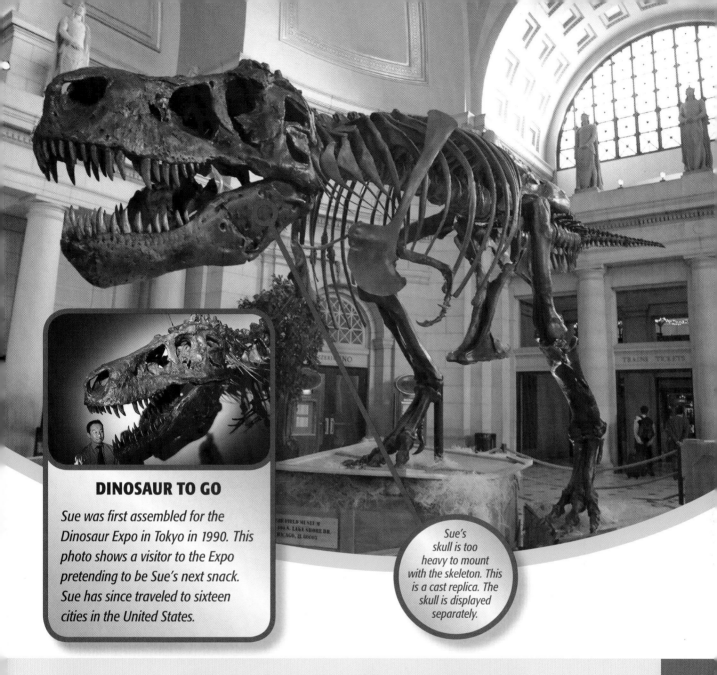

DINOSAUR TO GO

Sue was first assembled for the Dinosaur Expo in Tokyo in 1990. This photo shows a visitor to the Expo pretending to be Sue's next snack. Sue has since traveled to sixteen cities in the United States.

Sue's skull is too heavy to mount with the skeleton. This is a cast replica. The skull is displayed separately.

One Scary Lady?

Sue stands **13 ft.** (4 m) tall and measures **41 ft.** (12.5 m) long—imagine her trying to find a dress to fit! She's got teeth a foot long! And Sue weighs **14,110 lbs.** (6,400 kg), though at this point, a diet won't help. Sue's not a person, of course, but she is the **WORLD'S LARGEST AND MOST COMPLETE T-REX SKELETON**.

Discovered in South Dakota on August 12, 1990, by fossil hunter Sue Hendrickson (yes, that's where the dino's name comes from), Sue has dazzled scientists and visitors to museums ever since. While other *Tyrannosaurus rex* skeletons have been found since the first turned up in 1900, Sue is the most complete and best-preserved. She is displayed permanently at the Field Museum in Chicago. However, while her name is Sue, no one is really sure if she's a boy *T-rex* or a girl *T-rex*!

ANIMALS

SUE LIVED IN THE LATE CRETACEOUS PERIOD. WAS THIS 10, 65, OR 200 MILLION YEARS AGO?

The Late Cretaceous period was about 65 million years ago.

EWWW! COCKROACH!

The **World's Largest Winged Cockroach** *is* Megaloblatta longipennis, *which lives in Peru, Ecuador, and Panama. One measured 3.8 in. (11 cm) and they can weigh 2.5 to 3.5 oz. (70 to 100 g). This giant fellow here is another big insect, the Australian burrowing cockroach.*

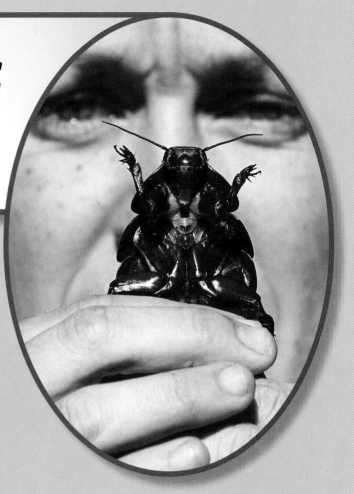

HOPE THAT'S NOT AN EGG

*No, it's not an insect egg . . . whew! Pictured here is Yoichiro Kawamura of Japan with the **World's Largest Wasp Nest**. Yoichiro found this in 1999 in Japan. It was measured at an astounding 8 ft. (2.45 m) around. It weighed 17 lbs. 8 oz. (8 kg). Wasps build nests out of chewed-up wood pulp and, well, wasp spit.*

BIG GLASS OF TOAD

*The **Largest Species of Toad** in the world is the cane or marine toad, which lives in parts of Australia. These big hoppers average as much as 1 lb. (450 g)! One giant specimen (not this unhappy-looking dude) weighed 5 lbs., 13.8 oz. (2.65 kg) in 1991.*

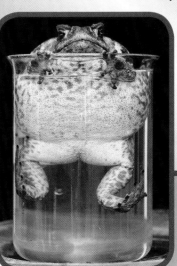

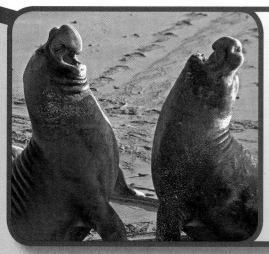

THE ELEPHANT OF SEALS

*Time to learn a new word: The collective term for the family of animals that includes seals and walruses is pinniped. The **World's Largest Species of Pinniped** is the huge (and loud!) elephant seal. The males average 16 ft. 6 in. (5 m) and can weigh about 4,400 to 7,720 lbs. (2,000 to 2,500 kg)! They also have enormous bellowing voices that they use to announce their presence!*

LONGEST INSECT

*If you ever see this crawling up your friend's neck . . . make sure to break the news gently! This type of stick insect from Borneo is the **Longest Species of Insect** in the world. The body of a specimen in a London museum was measured at 12.9 in. (328 mm). If you add in the legs, the insect stretches to more than 21.5 in. (54 cm)!*

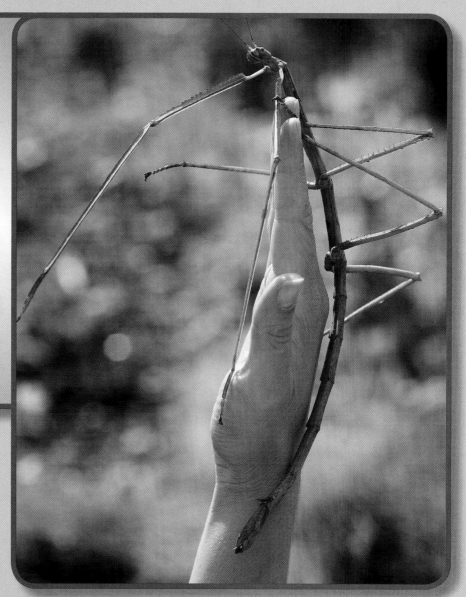

47

Food

After reading about all the biggest people and animals in the world, you're probably hungry, right? Well, you've come to the right place. In this chapter, you'll see the world's, largest, tallest, biggest, and most gigantic food. Step up to the table . . . and bring a BIG appetite!

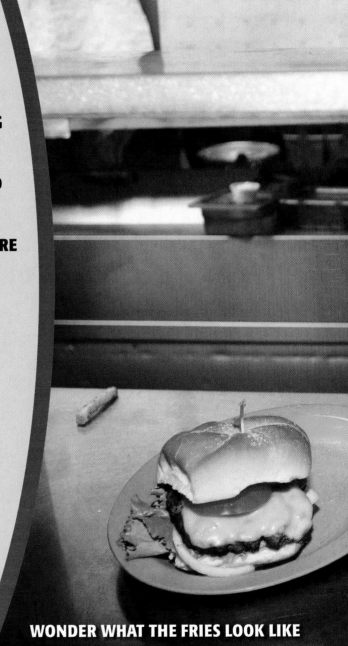

WONDER WHAT THE FRIES LOOK LIKE

How big is this gigantic meal—the World's Largest Hamburger? See page 61 for the answer. Here's a hint: You get a prize just for finishing one!

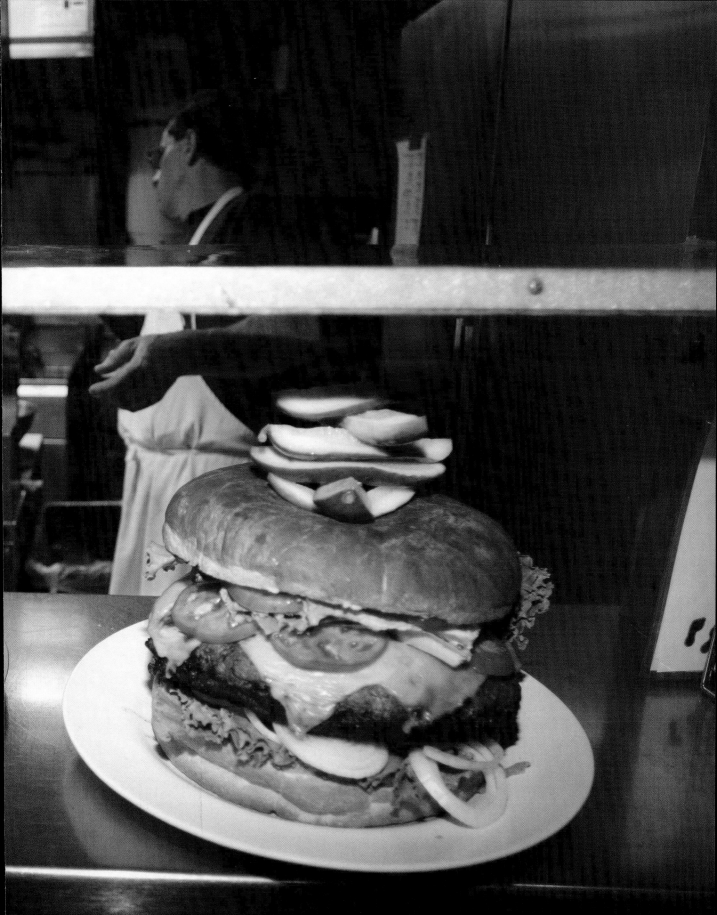

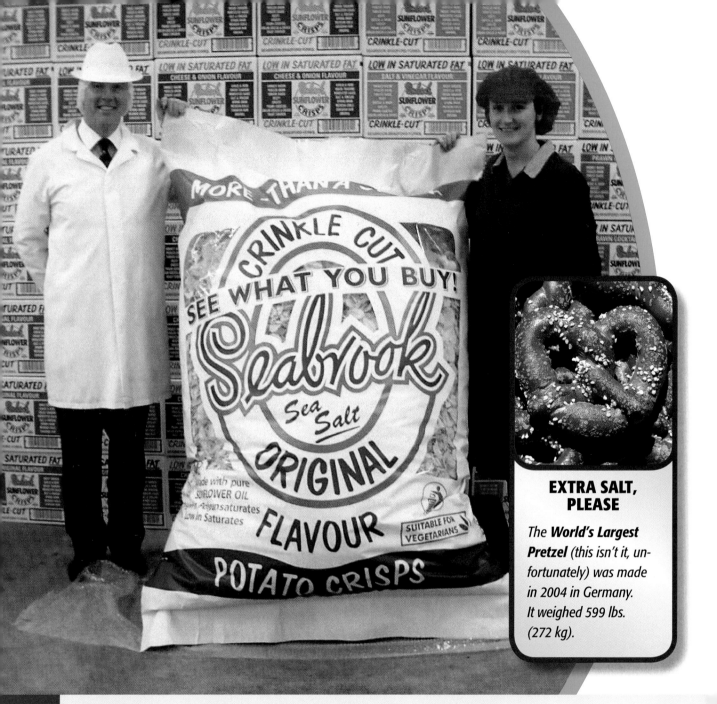

EXTRA SALT, PLEASE

*The **World's Largest Pretzel** (this isn't it, unfortunately) was made in 2004 in Germany. It weighed 599 lbs. (272 kg).*

Where's the Dip?

When potato chips (or potato crisps, as they're known in Great Britain) are your life, you want to celebrate them when you can. That's why the folks at Seabrook Potato Crisps Ltd. decided to create this monster of a snack food: It's the **WORLD'S LARGEST POTATO CHIPS BAG**.

The bag contains **113 lbs. 3 oz.** (51.35 kg) of chips, which are salted and crinkle cut. The bag itself stands **5.87 ft.** (1.79 m) and is **3.96 ft.** (1.21 m) wide.

And don't ask your mom to pack them in your lunch. Not surprisingly, this big bag contains more than 275,000 calories!

TRUE OR FALSE: POTATO CHIPS WERE INVENTED IN 1853 BY A CHEF TRYING TO MAKE VERY CRISP FRENCH FRIES.

True: In Saratoga Springs, New York, Chef George Crum was trying to satisfy a complaining customer and ended up making up super-crisp potato chips.

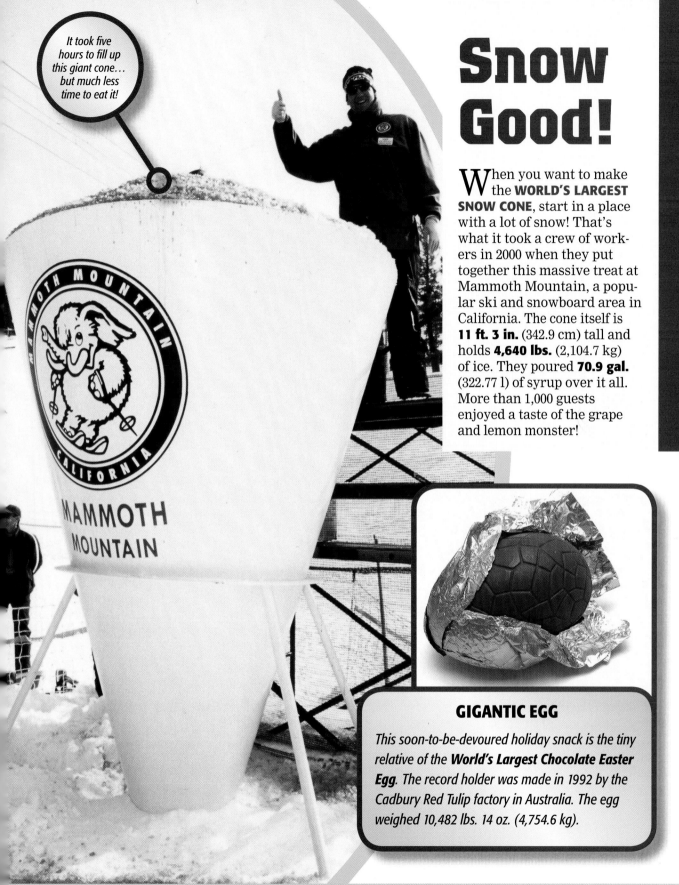

It took five hours to fill up this giant cone... but much less time to eat it!

Snow Good!

When you want to make the **WORLD'S LARGEST SNOW CONE**, start in a place with a lot of snow! That's what it took a crew of workers in 2000 when they put together this massive treat at Mammoth Mountain, a popular ski and snowboard area in California. The cone itself is **11 ft. 3 in.** (342.9 cm) tall and holds **4,640 lbs.** (2,104.7 kg) of ice. They poured **70.9 gal.** (322.77 l) of syrup over it all. More than 1,000 guests enjoyed a taste of the grape and lemon monster!

GIGANTIC EGG

*This soon-to-be-devoured holiday snack is the tiny relative of the **World's Largest Chocolate Easter Egg**. The record holder was made in 1992 by the Cadbury Red Tulip factory in Australia. The egg weighed 10,482 lbs. 14 oz. (4,754.6 kg).*

HOW DO YOU MAKE A SNOW CONE IF IT DOESN'T SNOW NEAR YOU?

Snow cones are shaved ice covered with sweet syrup.

Big Pile o' Burgers!

From January 1 to December 31—every single day—in every one of the 50 states—Donald Gorske has eaten a Big Mac. He has has eaten the famous meal every day for the past 33 years! He now holds the record for the **MOST BIG MACS CONSUMED**.

Donald has been keeping careful track of his Mac munching, too, and figures that he ate his **20,500th** Big Mac on March 27, 2005.

Along with hitting all the states, he's had his favorite food (we *hope* it's his favorite food!) in every NFL stadium, every Major League Baseball park, and even 23 NASCAR tracks!

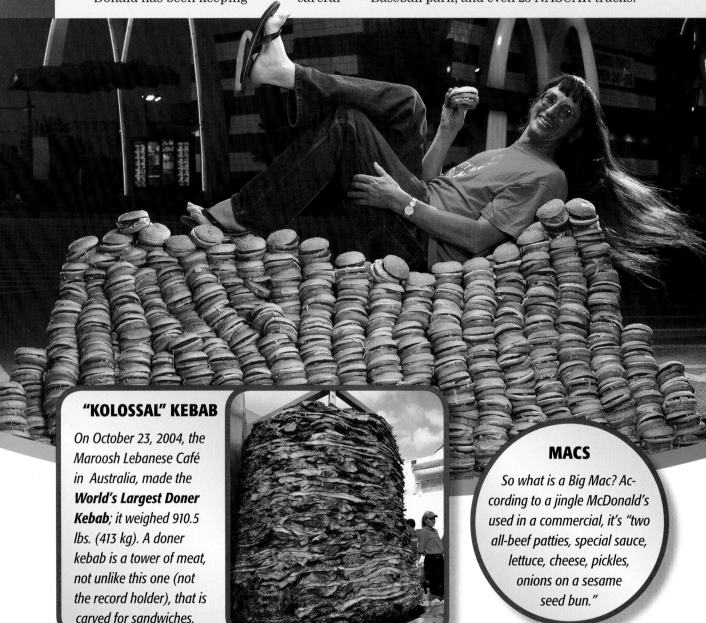

"KOLOSSAL" KEBAB

On October 23, 2004, the Maroosh Lebanese Café in Australia, made the **World's Largest Doner Kebab**; it weighed 910.5 lbs. (413 kg). A doner kebab is a tower of meat, not unlike this one (not the record holder), that is carved for sandwiches.

MACS

So what is a Big Mac? According to a jingle McDonald's used in a commercial, it's "two all-beef patties, special sauce, lettuce, cheese, pickles, onions on a sesame seed bun."

TRUE OR FALSE: THE FIRST BIG MAC WAS SERVED IN 1941.

False: Your grandparents couldn't enjoy Big Macs when they were kids. The Big Mac made its debut in 1968.

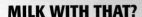

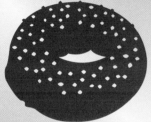

18:1 A regular bagel is about 4 inches across. This giant bagel is 18 times bigger across!

What a Bagel!

Seeing this picture of the **WORLD'S BIGGEST BAGEL** probably makes you think of two things: How will they fit that into the toaster? And where will they get enough cream cheese? Those are both questions that will never be answered, however; this bagel was just too darned big to toast or "shmear."

The old record bagel was 714 lbs. (323.86 kg), so the folks at Bruegger's Enterprises in Burlington, Vermont, knew they had their work cut out for them.

After carefully weighing their ingredients, they ended up with the record for biggest bagel, which was **6 ft.** (2 cm) in diameter, **20 in.** (45 cm) thick, and weighed **868 lbs.** (393 kg).

FOOD

TRUE OR FALSE: THE WORD "BAGEL" HAS SOMETHING TO DO WITH A HORSE.

Well, maybe true: One legend says the bagel's inventor named the food after the German word for stirrup, which is "beugal."

Want Butter?

Going to the movies usually means getting popcorn. It just doesn't seem right to sit in the dark with your friends and watch the latest blockbuster without a handful of buttery popcorn. In 2003, to celebrate the anniversary of the Allan Park Cinema, the folks in Stirling, United Kingdom, decided to honor the marriage of movies and popcorn. Using thousands of pounds of popcorn, they created the **WORLD'S LARGEST POPCORN SCULPTURE**.

Created to look like famed movie monster Godzilla (see the teeth?), it stands **16 ft. 0.5 in.** (4.89 m).

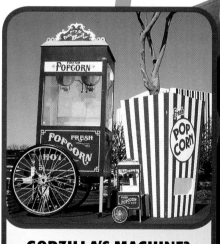

GODZILLA'S MACHINE?

*The **World's Largest Popcorn Machine** was built in 2004 by Greg Scott Abbott, Wink Eller, Lisa Lejohn, Eric Scarlett, Christoff Koon, and Charles Cretors. The big popper stands 22 ft. 2.75 in. (6.77 m) tall.*

HOW MUCH POPCORN DO AMERICANS EAT EACH YEAR, PER PERSON: 13, 54, OR 105 QUARTS.

Between trips to the movies and popcorn popped at home, Americans eat 54 pounds per person per year!

Dream Come True

The picture below is our fondest food dream come true. Made in Poland in 2004, this spectacular example of Italian cooking is the **WORLD'S LONGEST PIZZA**.

The Magillo Pizzeria got the help of a sports club (need a lot of people to sprinkle all that cheese!) and made a pizza that measured **440 ft. 6 in.** (134.27 m). Though only about **3 ft.** (1 m) wide, that means the pizza stretched longer than a football field! They covered it with **43.99 gal.** (220 l) of tomato sauce and **661.3 lbs.** (150 kg) of cheese.

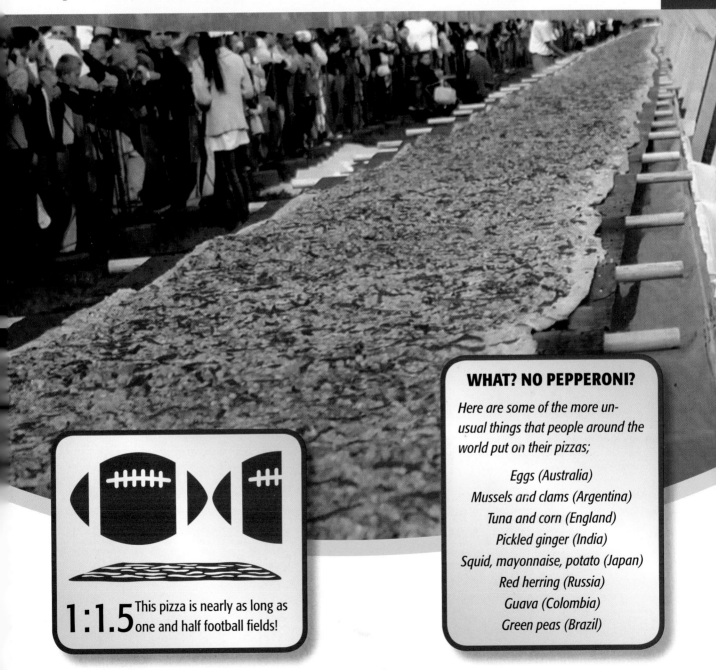

1:1.5 This pizza is nearly as long as one and half football fields!

WHAT? NO PEPPERONI?

Here are some of the more unusual things that people around the world put on their pizzas;

Eggs (Australia)
Mussels and clams (Argentina)
Tuna and corn (England)
Pickled ginger (India)
Squid, mayonnaise, potato (Japan)
Red herring (Russia)
Guava (Colombia)
Green peas (Brazil)

ABOUT HOW MANY PIZZAS ARE SOLD IN THE UNITED STATES EACH YEAR: 1 MILLION, 1 BILLION, OR 3 BILLION.

Stats show that more than 3 billion (with a "b"!) pizzas are sold each year.

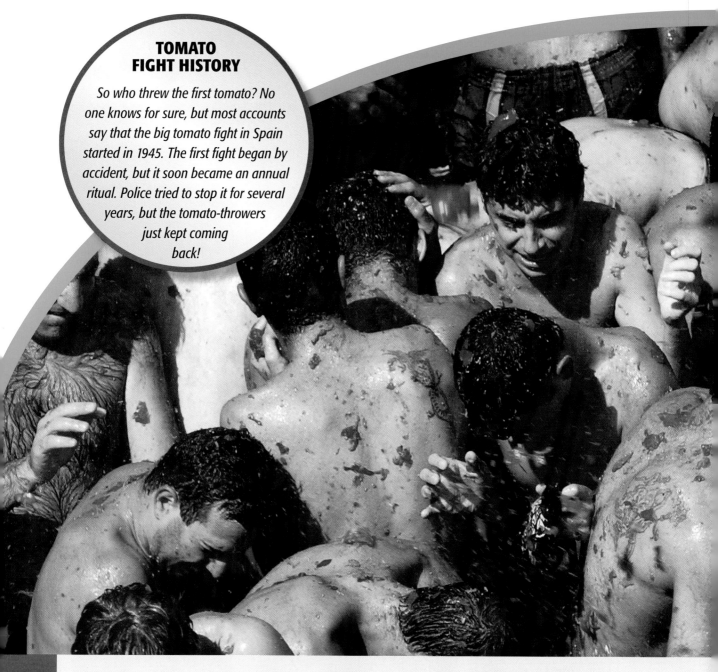

Ultimate Food Fight

Does this look like fun? If it does, then book your trip to Valencia, Spain, for the last Wednesday of August. That's when the tomato festival called La Tomatina includes the **WORLD'S LARGEST ANNUAL FOOD FIGHT**.

More than **25,000 people** take part each year, throwing **275,000 lbs.** (124,737 kg) of the squishy red fruits. Trucks actually drive through the square and the streets where the fight is held, dumping buckets full into the crowd.

How do they clean it all up? Good question. They bring in the fire department, which hoses down everything—and everyone!

FOOD

WHICH AMERICAN STATE PRODUCES THE MOST TOMATOES?

The warm sun and fertile soil of California is the source of 90 percent of America's tomatoes.

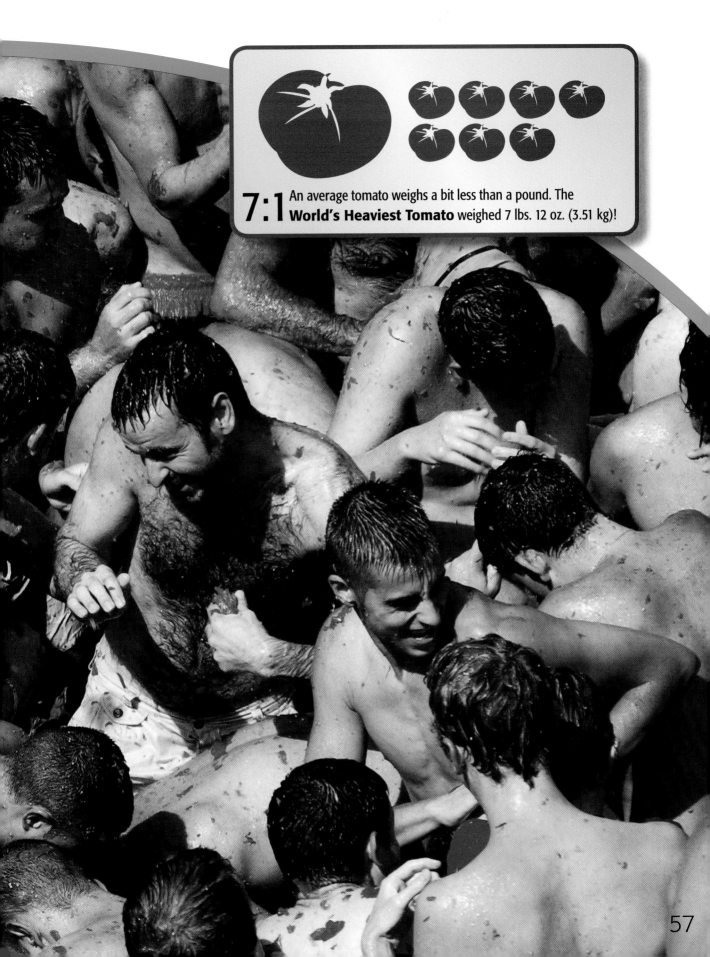

7:1 An average tomato weighs a bit less than a pound. The **World's Heaviest Tomato** weighed 7 lbs. 12 oz. (3.51 kg)!

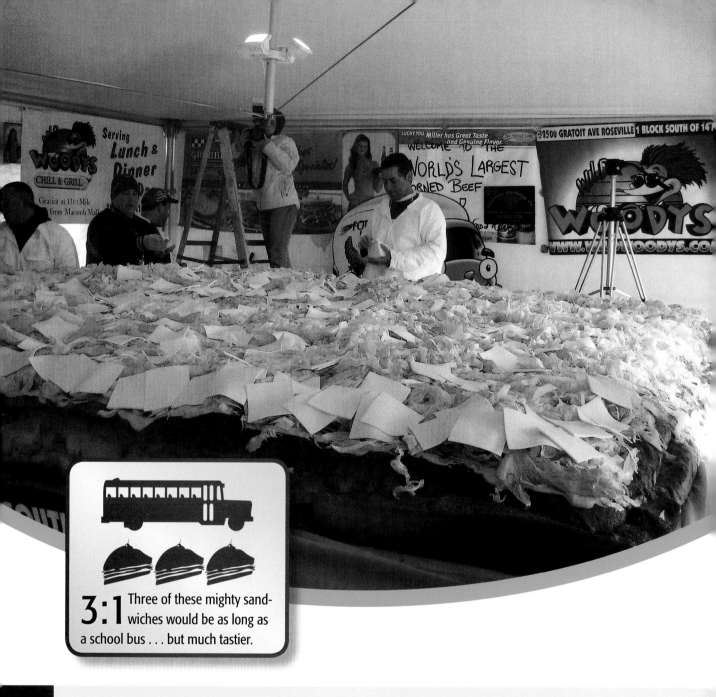

3:1 Three of these mighty sandwiches would be as long as a school bus . . . but much tastier.

Dagwood's Dream

The "Blondie" comic-strip character named Dagwood Bumstead is famous for making gigantic sandwiches (often in the middle of the night). Next time Dagwood is hungry, he should head to Wild Woody's Chill and Grill in Roseville, Michigan. There he could taste the **WORLD'S LARGEST SANDWICH**.

The sandwich was born on March 17, 2005, and weighed a groaning **5,440 lbs.** (2.467.5 kg) and was **12 ft.** (3.6 m) wide.

It had everything you expect in a giant sandwich: **1,032 lbs.** (468 kg) of corned beef, **530 lbs.** (240 kg) of lettuce, and **150 lbs.** (68 kg) of mustard, among other things.

FOOD

WHY DID WOODY'S CHOOSE CORNED BEEF TO PUT ON THEIR GIGANTIC SANDWICH? HINT: LOOK AT THE DATE.

Corned beef is traditionally served at restaurants on March 17, St. Patrick's Day!

Marry Me!

Have you ever been to a wedding? There's a funny tradition that the bride or groom take the first bite of a wedding cake—and smear it on each other's face! The happy couple who faced this gigantic treat could have smeared their whole body! This is the **WORLD'S LARGEST WEDDING CAKE**, made in 2004 at the Mohegan Sun Hotel in Connecticut. It weighed **15,032 lbs.** (6,818.40 kg).

The cake was so huge that chefs needed a cherry-picker to reach the top.

LOTS AND LOTS OF FRIENDS

This couple would have loved this cake. In 2003, Suresh Joachim was the **Groom with the Most Ushers** (47) and *Christa Rasanayagame was the* **Bride with the Most Bridesmaids** (79).

HOW LONG WAS THE WORLD'S LONGEST MARRIAGE: 70 YEARS, 80 YEARS, OR 86 YEARS?

86 years: In 1853, a couple in India were married when they were five (they did things like that back then). The husband died in 1940.

59

A Hot Dog for 60

An average-sized hot dog is about seven inches long. The talented food experts at Conshohocken Bakery and Berks Meat Packing said that that was just not enough! On August 14, 2005, to raise money for a kids' charity, they created the **WORLD'S LONGEST HOT DOG**! The massive weiner stretched out to a length of **57 ft. 6 in.** (17.5 m).

The old record doggie was about 18 ft. (4 m) shorter.

The photo below shows a different long hot dog, but you get the idea! The Conshohocken/Berks record holder was sliced up and sold to raise more than $500 for the Corvettes for Kids organization in Fogesville, Pennsylvania.

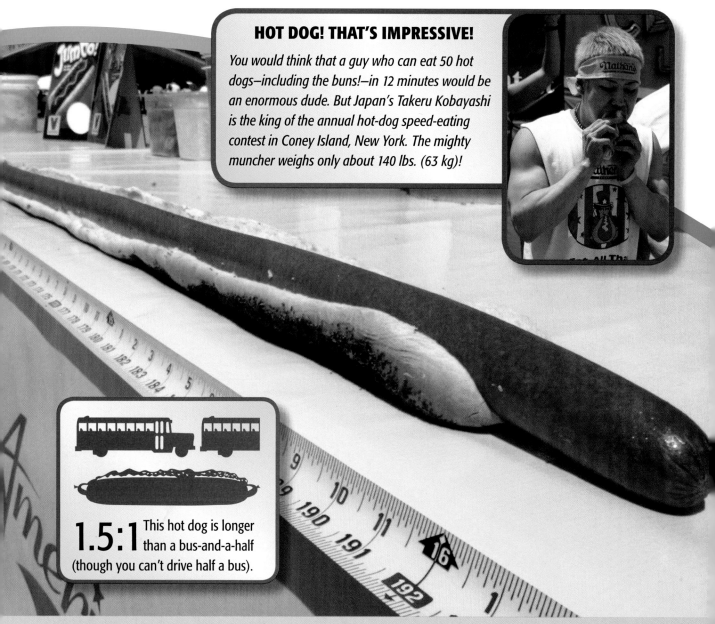

HOT DOG! THAT'S IMPRESSIVE!

You would think that a guy who can eat 50 hot dogs—including the buns!—in 12 minutes would be an enormous dude. But Japan's Takeru Kobayashi is the king of the annual hot-dog speed-eating contest in Coney Island, New York. The mighty muncher weighs only about 140 lbs. (63 kg)!

1.5:1 This hot dog is longer than a bus-and-a-half (though you can't drive half a bus).

HOW DID "HOT DOGS" GET THEIR NAME?

First called frankfurters, after the German city of Frankfurt, where similar sausages were sold, hot dogs got their popular name from a 1906 cartoon.

BURGER BLING-BLING

*For the price of about 30 fast-food burgers ($120), you can get the **World's Most Expensive Hamburger**. The DB Double Truffle Burger is made by Daniel Boulud. Why so costly? It's made with truffles, a type of underground fungus related to the mushroom.*

Big Mouth

A big mouth: That's what you'll need when you visit Denny's Beer Barrel Pub in Clearfield, Penn. If you're truly hungry, feel free to order this mighty meal. At **9 lbs**. (4 kg), this pile of food is Ye Old 96er, the **WORLD'S LARGEST HAMBURGER** that you can order in a restaurant. (Note: Larger burgers have been made, but they were special creations.) The picture on page 48 shows the record-holder next to a regular-sized burger. If you do manage to finish, you'd be the first, and you'd get your name on a plaque at Denny's.

18:1 A typical hamburger is about a half-pound, so it would take 18 to equal this monster.

How much does it cost to impress your pals by ordering this? $23.95.

WHERE DOES THE NAME "HAMBURGER" COME FROM?

A German city was famous for many years for its beef products. Its name carried through the years. The city? Hamburg!

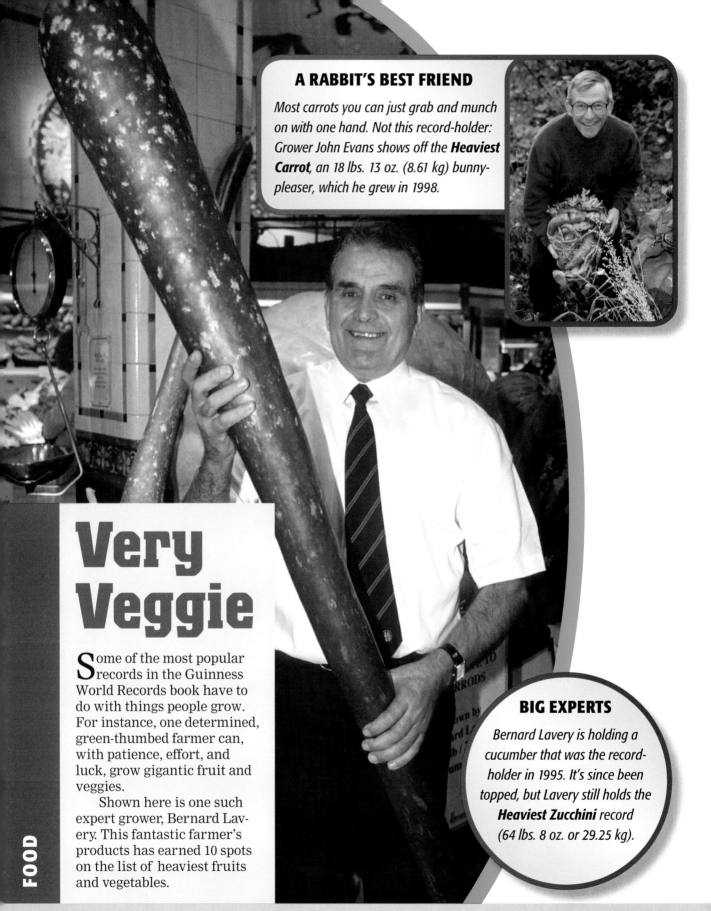

A RABBIT'S BEST FRIEND

*Most carrots you can just grab and munch on with one hand. Not this record-holder: Grower John Evans shows off the **Heaviest Carrot**, an 18 lbs. 13 oz. (8.61 kg) bunny-pleaser, which he grew in 1998.*

Very Veggie

Some of the most popular records in the Guinness World Records book have to do with things people grow. For instance, one determined, green-thumbed farmer can, with patience, effort, and luck, grow gigantic fruit and veggies.

Shown here is one such expert grower, Bernard Lavery. This fantastic farmer's products has earned 10 spots on the list of heaviest fruits and vegetables.

BIG EXPERTS

*Bernard Lavery is holding a cucumber that was the record-holder in 1995. It's since been topped, but Lavery still holds the **Heaviest Zucchini** record (64 lbs. 8 oz. or 29.25 kg).*

WHAT IS THE BIGGEST FRUIT OR VEGETABLE IN THE GUINNESS WORLD RECORD BOOK: PUMPKIN, CANTALOUPE, OR SQUASH.

The world's biggest pumpkin, at 1,446 pounds (655.9 kg) is also the biggest item on the list.

Give Us a Spoon!

How's this for a birthday cake! When you're a leading ice cream maker and your company turns 70 years old, you get to make this, the **WORLD'S LARGEST ICE CREAM CAKE** to celebrate the event!

The Carvel Corporation built this icy monster, which weighed **12,096 lbs.** (5,486.7 kg). It was **19 ft.** (6.2 m) long, **9 ft.** (3 m) wide, and **2 ft.** (60 cm) tall. Amazingly, the entire giant confection took 54 workers only 75 minutes to put together. Of course, when you consider that it was melting at the same time, they had to work fast! A special ice cream sheet cake was held at a temperature of –120° F! Hundreds of people got a taste of the cake when it was unveiled in New York City on May 25, 2004.

GOOD PLACES TO VISIT!

According to ice cream industry folks, these are the top ten ice-cream consuming countries in the world.

1. United States
2. New Zealand
3. Denmark
4. Australia
5. Belgium
6. Sweden
7. Canada
8. Norway
9. Ireland
10. Switzerland

Fudgie the Whale is the official "spokescake" of the Carvel Corp.!

TRUE OR FALSE: ICE CREAM HEADACHES ARE CAUSED BY THE SUGAR IN ICE CREAM.

False: Those stinging pains you get when eating ice cream too fast come from blood vessels in your head shrinking.

Powerful Pie!

The old saying goes that some things are "as American as apple pie." In 1997, a hard-working American team of bakers, fruit-slicers, and others created the **WORLD'S LARGEST APPLE PIE**.

At Walla Walla Park in Wenatchee, Washington, a group from the North Washington Museum sliced, diced, spread, rolled, and baked an apple pie that ended up weighing **34,438 lbs.** (15,620 kg). It was in a pan that was **44 ft.** (13.4 m) long and **24 ft.** (7.3 m) wide. You can't get more American than this!

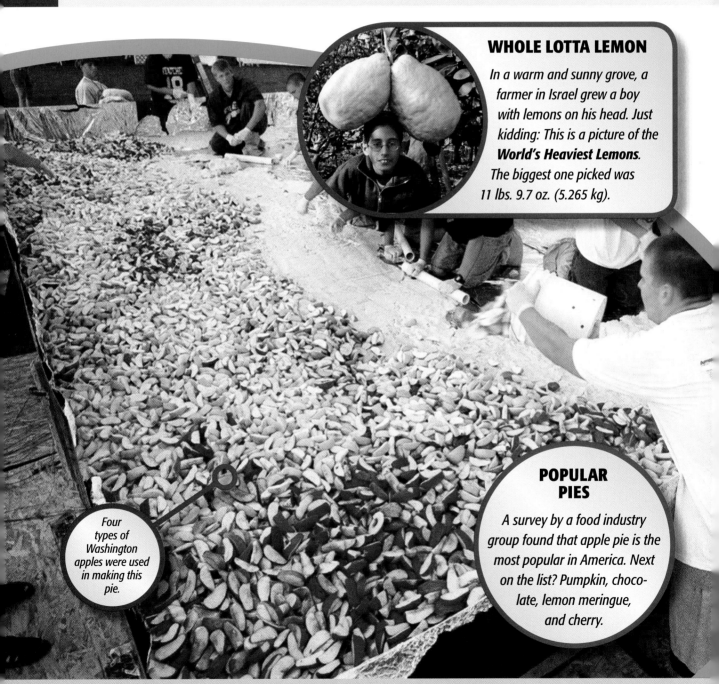

WHOLE LOTTA LEMON

*In a warm and sunny grove, a farmer in Israel grew a boy with lemons on his head. Just kidding: This is a picture of the **World's Heaviest Lemons**. The biggest one picked was 11 lbs. 9.7 oz. (5.265 kg).*

Four types of Washington apples were used in making this pie.

POPULAR PIES

A survey by a food industry group found that apple pie is the most popular in America. Next on the list? Pumpkin, chocolate, lemon meringue, and cherry.

WHO EATS MORE APPLES, AMERICANS OR EUROPEANS?

The surprise answer is Europeans. They eat about 46 pounds per person, compared to 19 pounds per person in the United States.

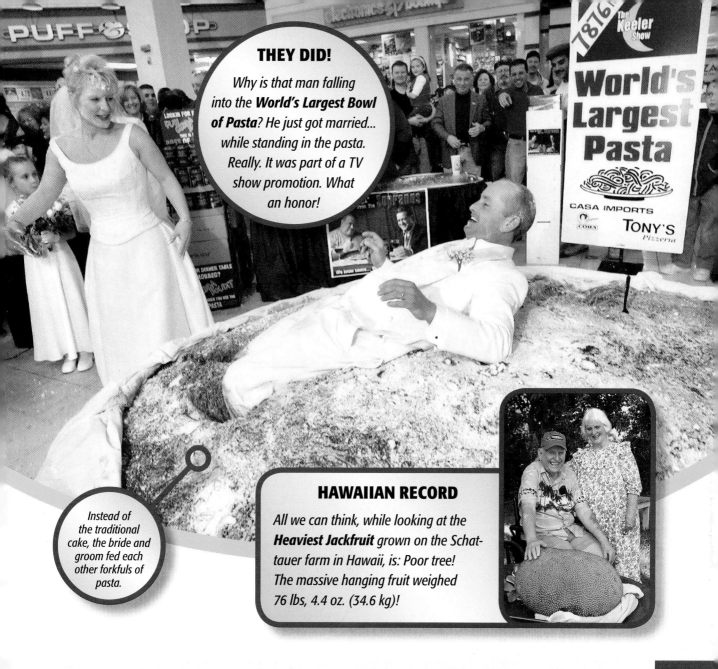

THEY DID!

*Why is that man falling into the **World's Largest Bowl of Pasta**? He just got married... while standing in the pasta. Really. It was part of a TV show promotion. What an honor!*

HAWAIIAN RECORD

*All we can think, while looking at the **Heaviest Jackfruit** grown on the Schattauer farm in Hawaii, is: Poor tree! The massive hanging fruit weighed 76 lbs, 4.4 oz. (34.6 kg)!*

Instead of the traditional cake, the bride and groom fed each other forkfuls of pasta.

Super Spaghetti!

People always dream of the perfect wedding. All your friends and family, a beautiful service, an elegant gown . . . and the **WORLD'S LARGEST BOWL OF PASTA**.

Okay, that last one is not part of most people's dreams, but one lucky couple in Hartford, New York, got just that as part of their wedding in 2004. A TV show sponsored a contest that would give the winners a chance to have their marriage ceremony performed while, um, standing in the record-setting bowl.

A couple named Lisa and Steve were the winners of the contest and on February 14 (nothing says "Happy Valentine's Day!" like enough spaghetti to feed a small town!), they were wed in red sauce.

The record-setting bowl itself held **7,355 lbs.** (3,336 kg) of pasta.

FOOD

TRUE OR FALSE: PASTA ORIGINATED IN CHINA.

Actually, most experts think that's true. Explorers from Italy brought pasta back to Europe from Asia in the 1400s.

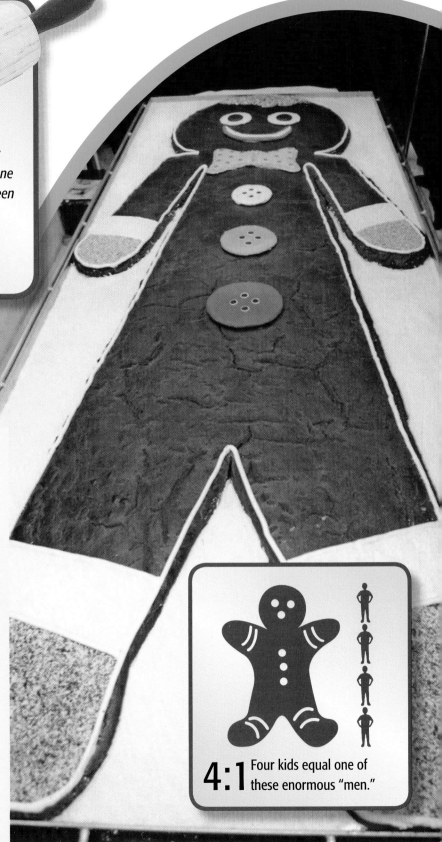

Flat Manly

This gigantic brown, frosting-covered guy would have made that old nursery rhyme a much scarier adventure. Can you imagine a **13-ft. 11-in.** (4.23-m) tall, **372-lb.** (168.8-kg) figure racing down the road shouting, "You can't catch me, I'm the **WORLD'S LARGEST GINGERBREAD MAN.**" At that size, we wouldn't *want* to catch him! This record-breaker was created in 2003 by chefs at the Hyatt Regency Hotel in Vancouver, Canada.

4:1 Four kids equal one of these enormous "men."

FOOD

IN THE FAMOUS NURSERY RHYME, WHAT HAPPENS TO THE GINGERBREAD MAN WHO CLAIMS THAT HE CAN'T BE CAUGHT?

66

He is tricked by a fox into hitching a ride across a stream . . . and the fox eats him!

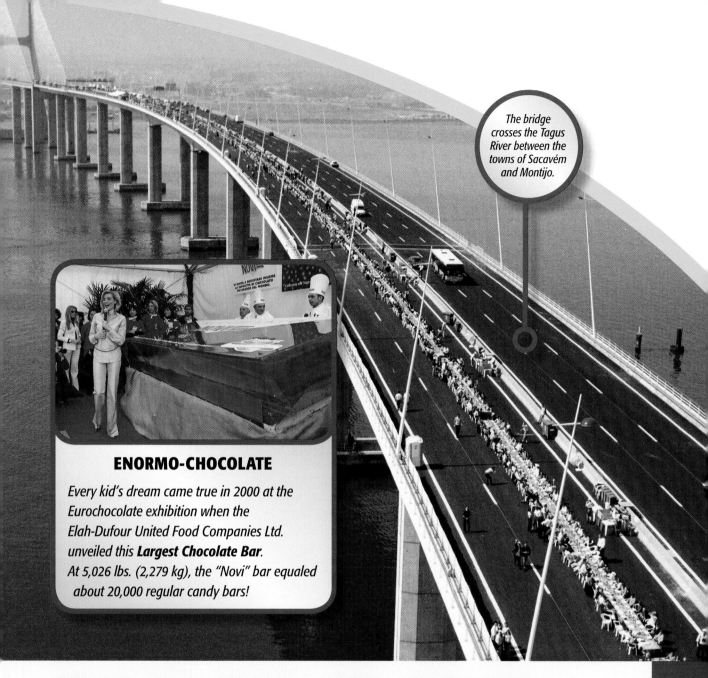

The bridge crosses the Tagus River between the towns of Sacavém and Montijo.

ENORMO-CHOCOLATE

*Every kid's dream came true in 2000 at the Eurochocolate exhibition when the Elah-Dufour United Food Companies Ltd. unveiled this **Largest Chocolate Bar**. At 5,026 lbs. (2,279 kg), the "Novi" bar equaled about 20,000 regular candy bars!*

Table for 15,000?

This entire chapter has been about really big things from the world of food. As we head toward the end, it's time to unveil the perfect place to eat all those gigantic meals: the **WORLD'S LONGEST CONTINUOUS TABLE**.

Seen here in an aerial photo taken on March 22, 1998, the massive table stretched **3 miles** (5.05 km) across the Vasco de Gama Bridge in Lisbon, Portugal.

Once the table was set up, 15,000 hungry people sat down to eat a meal served by (a very busy!) catering company.

The Vasco de Gama Bridge, which had just been completed before this record-setting table was built, holds a sort of record of its own. At 11 miles (18 km) long, it is the longest bridge in Europe.

TRUE OR FALSE: CHOCOLATE IS MINED, LIKE COAL.

False! Chocolate is made from cocoa beans, a type of plant.

OPEN WIDE . . . VERY WIDE!

Nick Calderaro of the Oak Leaf Confection Co. in Canada took 476 hours to make this **World's Largest Jawbreaker** in 2003. The candy weighs 27.8 lbs. (12.6 kg) and was 37.25 in. (94.6 cm) around.

FLOWERS IN A FOOD CHAPTER?

Well, what better way to dress up our "Food" table than flowers? Shown here is the site of the **World's Largest Flower Auction** in Aalsmeer, Netherlands; it's as big as 165 football fields!

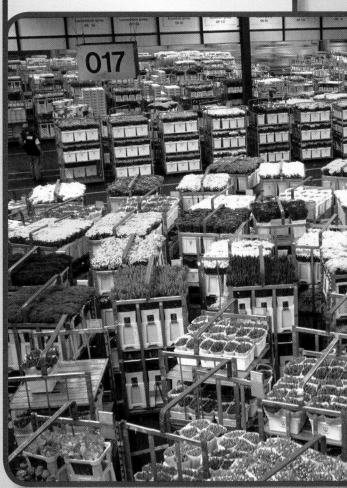

MUCH, MUCH BIGGER

This lollipop-loving kid has scored a pretty big treat, but it is nothing compared to the **World's Largest Lollipop**. On July 27, 2003, the Franssons company in Sweden debuted a lolly that was 6 ft. 6 in. (1.98 m) wide, 9 ft. 10 in. (3 m) long, and weighed 4,759.1 lbs. (2,158 kg).

THINGS ARE BIGGER IN TEXAS!

They say that everything is bigger in Texas. This picture shows the **World's Largest Piece of Toffee**, which was made in 2002, in the shape of Texas itself! Susie's South Forty Confections Inc. cooked up this pecan toffee, which weighed 2,940 lbs. (1,335 kg) and contained a total of 7,056,000 calories!

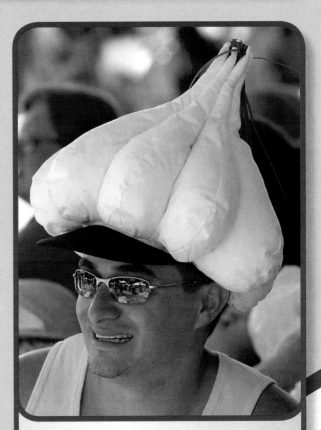

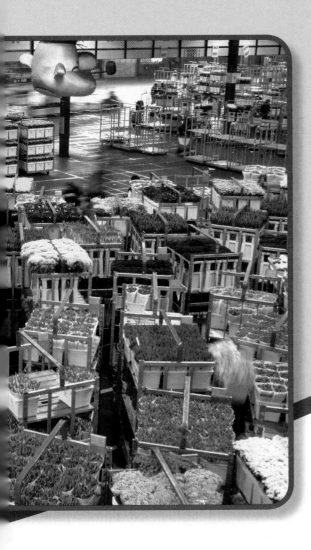

GOTTA LOVE GARLIC!

Food festivals are popular events all around the world. Communities celebrate a particular food for which their area is known. The **World's Largest Garlic Festival** (that's a garlic hat above) is held each year in Gilroy, California. More than 130,000 garlic-lovers attend.

Buildings and Land

Some of the most monumentally BIG things in the world (and thus, in this book) are the creations of man and nature. Man made the buildings that tower over cities; nature created enormous wonders around the globe. In this chapter, we'll take a look at some of the BIGGEST, TALLEST, HUGEST buildings, structures, and parts of our Earth.

ONE GREAT WALL

The Great Wall of China remains one of the world's manmade wonders and a key tourist stop for visitors to China (page 76).

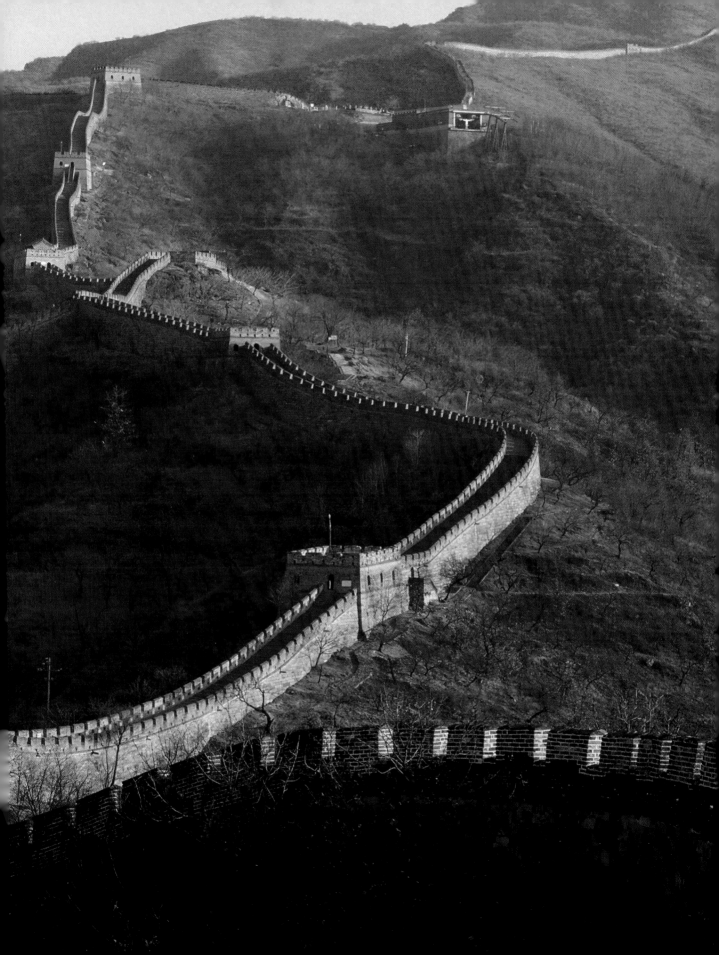

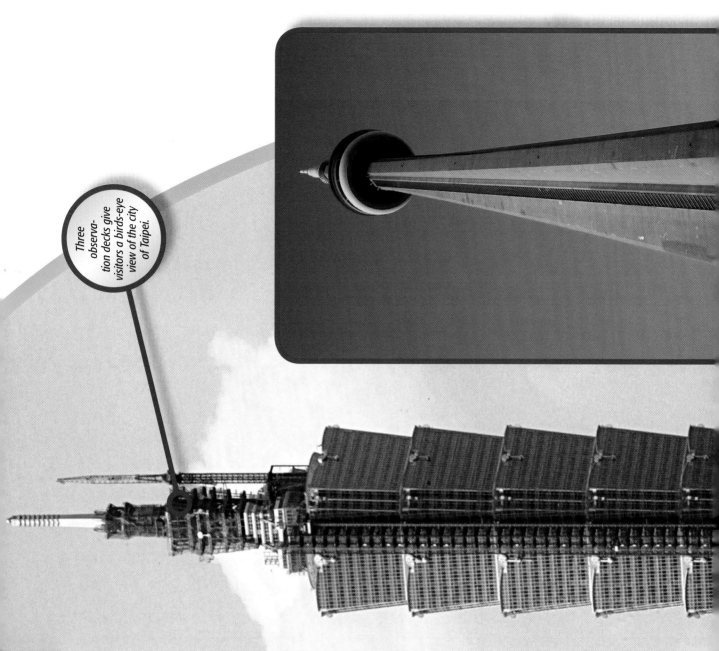

Three observation decks give visitors a birds-eye view of the city of Taipei.

101 Is No. 1

Soaring high above the sky-line of Taipei, the capital of the island nation of Taiwan, is the magnificent Taipei Financial Center. Known by the nickname of Taipei 101, it is the **WORLD'S TALLEST BUILDING.**

Finally completed in 2004, Taipei 101 stands **1,666 ft.** (508 m), and has **101 stories** (or floors). The building is so tall that it has an enormous iron pendulum that weighs 198,000 lbs. (89,811 kg) inside it to help keep it stabilized in high winds. The **WORLD'S FASTEST ELEVATOR** whisks visitors from the bottom level to the 89th floor in only **40 seconds.** That's about **37.6 mph** (60.6 km/h).

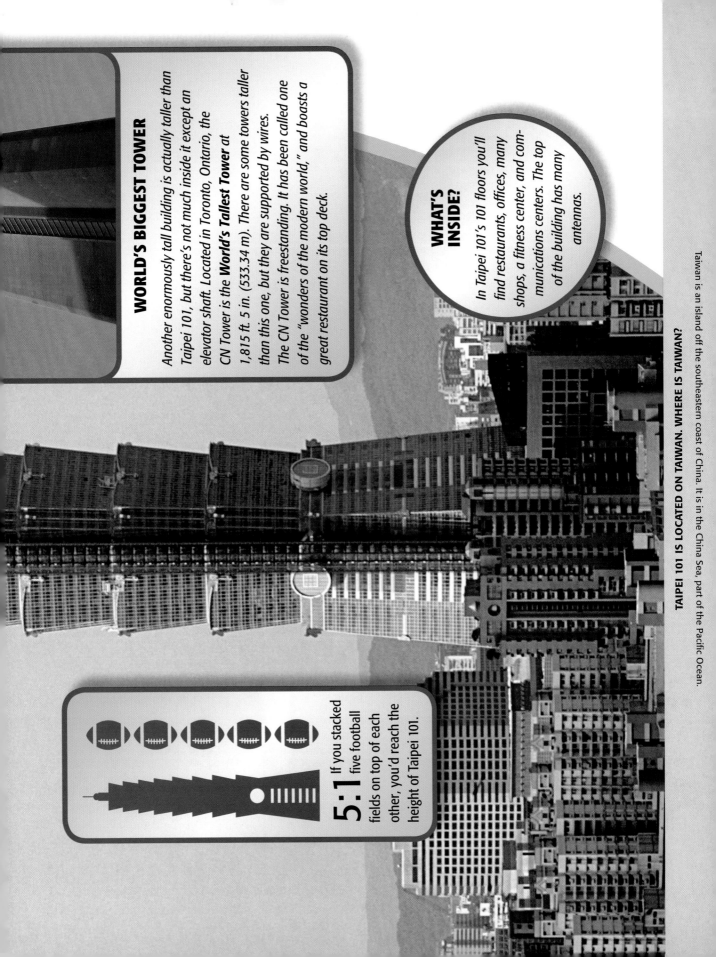

WORLD'S BIGGEST TOWER

Another enormously tall building is actually taller than Taipei 101, but there's not much inside it except an elevator shaft. Located in Toronto, Ontario, the CN Tower is the **World's Tallest Tower** *at 1,815 ft. 5 in. (533.34 m). There are some towers taller than this one, but they are supported by wires. The CN Tower is freestanding. It has been called one of the "wonders of the modern world," and boasts a great restaurant on its top deck.*

WHAT'S INSIDE?

In Taipei 101's 101 floors you'll find restaurants, offices, many shops, a fitness center, and communications centers. The top of the building has many antennas.

5:1

If you stacked five football fields on top of each other, you'd reach the height of Taipei 101.

TAIPEI 101 IS LOCATED ON TAIWAN. WHERE IS TAIWAN?

Taiwan is an island off the southeastern coast of China. It is in the China Sea, part of the Pacific Ocean.

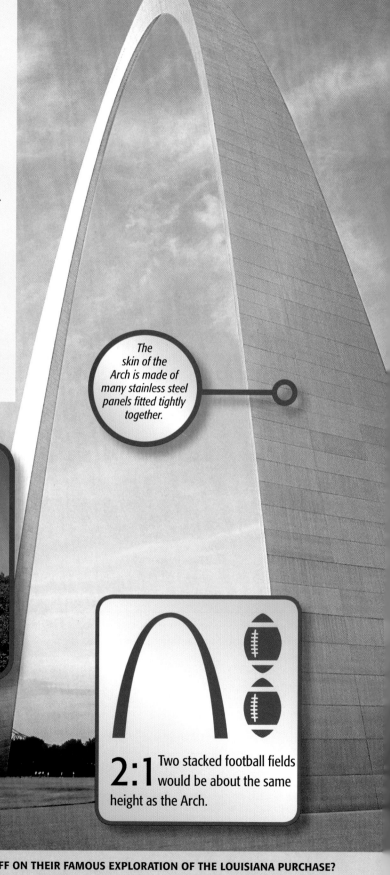

It's One Big Arch

Yes, there is just one and no, it is not golden! This massive, curving steel structure is the Gateway Arch, in St. Louis, Missouri, on the banks of the mighty Mississippi. With a sweeping arch span of **630 ft.** (192 m), the Arch is the **WORLD'S TALLEST MONUMENT**. It's a monument to the Westward Expansion of the United States (after the Louisiana Purchase), and St. Louis was the jumping-off point for the 1802-1804 Lewis & Clark expedition. The arch symbolizes St. Louis's status as the gateway to the West.

The Gateway Arch was designed by architect Eero Saarinen, and opened to the public on October 28, 1965.

The skin of the Arch is made of many stainless steel panels fitted tightly together.

BIGGEST OBELISK

*The Washington Monument— located in Washington, D.C., of course, and named for (all together now) George Washington—is the **World's Tallest Obelisk** at 555 ft. (169 m). An obelisk is a four-sided pillar topped by a pyramid. They were popular in ancient Egypt.*

2:1 Two stacked football fields would be about the same height as the Arch.

WHICH AMERICAN PRESIDENT SENT LEWIS & CLARK OFF ON THEIR FAMOUS EXPLORATION OF THE LOUISIANA PURCHASE?

President Thomas Jefferson.

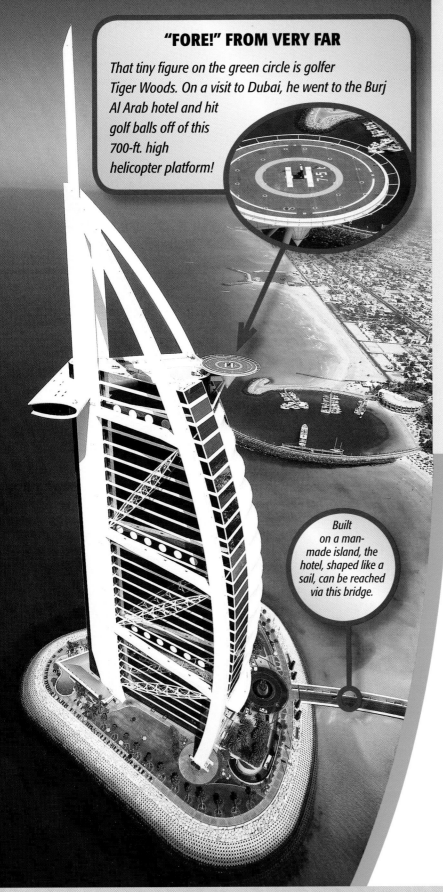

"FORE!" FROM VERY FAR

That tiny figure on the green circle is golfer Tiger Woods. On a visit to Dubai, he went to the Burj Al Arab hotel and hit golf balls off of this 700-ft. high helicopter platform!

Built on a man-made island, the hotel, shaped like a sail, can be reached via this bridge.

High Hotel

Built in 1999, the Burj Al Arab (translation: The Arabian Hotel) towers **1,052 ft.** (320.94 m) over the Persian Gulf in Dubai in the United Arab Emirates. It's also the **WORLD'S TALLEST HOTEL!** Putting this gigantic hotel together took 3,500 designers, engineers, and construction workers.

They had to pound giant poles 131 ft. (40 m) deep into the seabed to hold it all up!

The atrium inside the hotel features a waterfall that is 597 ft. (182 m) tall!

3:1 A stack of 3 football fields (represented by footballs here) would equal the height of this hotel.

THIS HOTEL IS ON THE RED SEA. AT THE RED SEA'S NORTHERN END IS THE WORLD'S LONGEST WHAT?

The Suez Canal, which links the Red and Mediterranean Seas, is the World's Longest Ship Canal at 100.8 miles (162.2 km) long.

A Well-Named Wall

How big is the Great Wall of China? The wall is so huge, it is one of the largest manmade structures in the history of the world! At a length of **2,150 mi.** (3,460 km), the well-named Great Wall is the **WORLD'S LONGEST WALL**.

The Wall is not one continuous building but a series of walls stretching for hundreds of miles at a time.

It's almost as old as it is long, too. The Great Wall was primarily built from 221 to 210 B.C. during the reign of the emperor Qin Shi Huangdi, but some parts are 500 years older or as recent as the 1600s.

How tall is it? Well, that varies. Along its wandering route, it is actually made of different sections. Some are as tall as **39 ft.** (12 m), while other parts stand only **15 ft.** (4.5 m).

The Great Wall remains a hugely popular tourist attraction, drawing the attention of celebrities, politicians, traveling sports teams, and regular visitors. The main visitor center is about a two-hour drive from the Chinese capital city of Beijing.

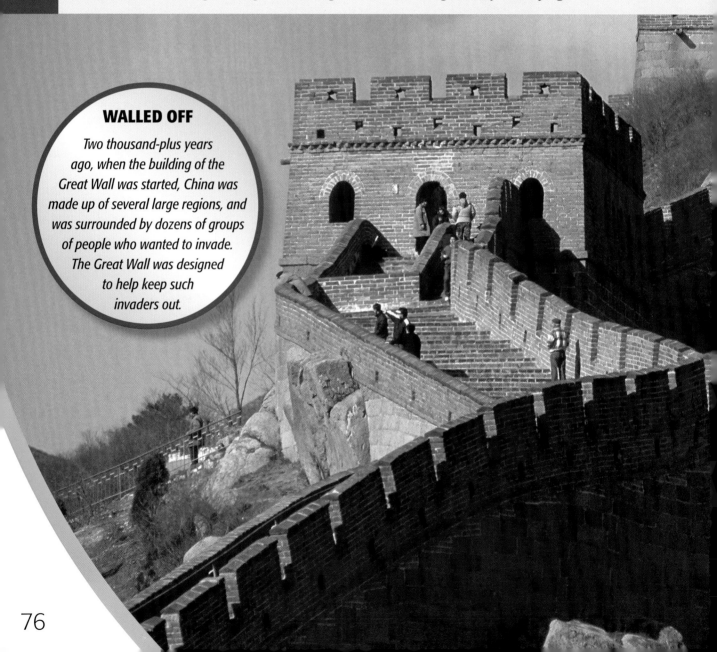

WALLED OFF

Two thousand-plus years ago, when the building of the Great Wall was started, China was made up of several large regions, and was surrounded by dozens of groups of people who wanted to invade. The Great Wall was designed to help keep such invaders out.

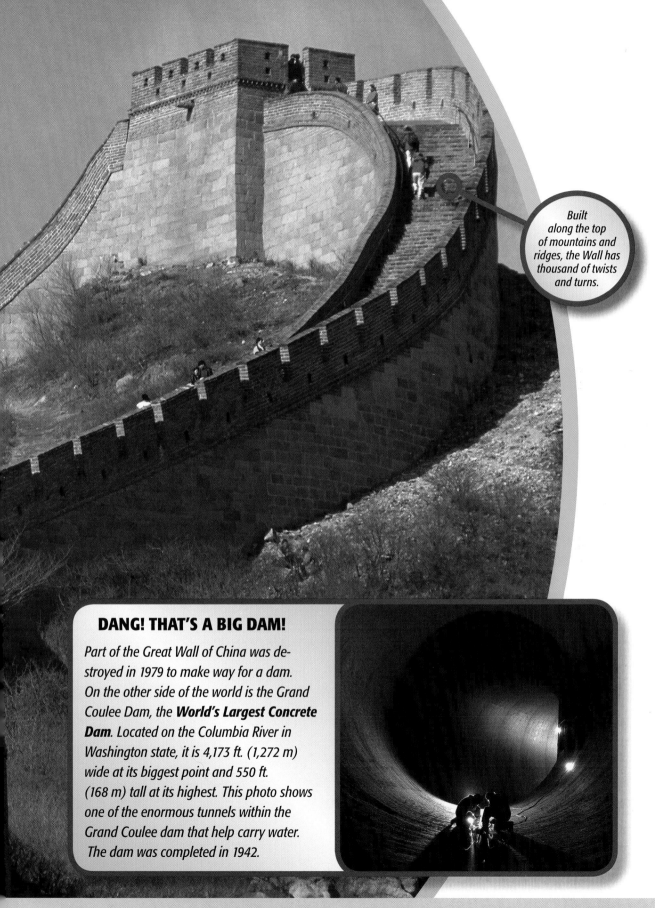

Built along the top of mountains and ridges, the Wall has thousand of twists and turns.

DANG! THAT'S A BIG DAM!

Part of the Great Wall of China was destroyed in 1979 to make way for a dam. On the other side of the world is the Grand Coulee Dam, the **World's Largest Concrete Dam**. Located on the Columbia River in Washington state, it is 4,173 ft. (1,272 m) wide at its biggest point and 550 ft. (168 m) tall at its highest. This photo shows one of the enormous tunnels within the Grand Coulee dam that help carry water. The dam was completed in 1942.

WHAT UNUSUAL EVENT ATTRACTS THOUSANDS OF SNEAKER-WEARING PEOPLE TO THE GREAT WALL EACH SPRING?

The annual Great Wall Marathon, a running race!

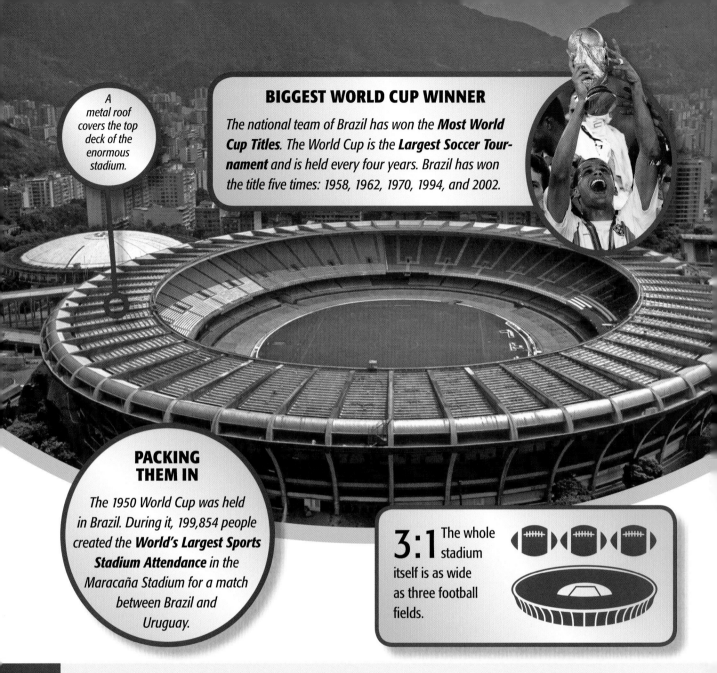

BIGGEST WORLD CUP WINNER

The national team of Brazil has won the **Most World Cup Titles**. The World Cup is the **Largest Soccer Tournament** and is held every four years. Brazil has won the title five times: 1958, 1962, 1970, 1994, and 2002.

A metal roof covers the top deck of the enormous stadium.

PACKING THEM IN

The 1950 World Cup was held in Brazil. During it, 199,854 people created the **World's Largest Sports Stadium Attendance** in the Maracaña Stadium for a match between Brazil and Uruguay.

3:1 The whole stadium itself is as wide as three football fields.

It's Just the Ticket

It sure is fun to spend a beautiful day at a stadium watching a top-notch sporting event. The best thing about the enormous Maracaña Municipal Stadium in Rio de Janiero, Brazil, is that you can take thousands of your closest friends with you to watch the game! That's because the legendary Maracaña is the **WORLD'S LARGEST SOCCER STADIUM**.

When every seat is filled, **205,000 people** can pack the place, almost twice as many as the largest similar stadium in the United States. The roof is **105 ft.** (32 m) high while the distance from the middle of the field to the furthest spectator is **413 ft.** (126 m).

Four different Rio-based Brazilian pro soccer teams play their home games in the Maracaña.

WAS THE LONGEST SOCCER MARATHON LONGER OR SHORTER THAN 12 HOURS?

Longer: The **Longest Soccer Marathon** was 26 hours, 24 minutes between the Tyson and Snickers teams on August 19-20, 2005.

What's Maya for Big?

One answer to that question is Quetzal-cóatl [kets-al-koh-AH-tul], the Maya language name given to the **WORLD'S LARGEST PYRAMID**.

Located 63 miles (101 km) southeast of what is today Mexico City, Quetzalcóatl was built by the Maya to honor Kukulkan, the feathered serpent god.

As the Maya were very interested in the stars and the calendar, the pyramid has exactly 365 steps (one for each day of the year) and is divided into 18 segments (the Maya calendar had that many months).

The pyramid stands **177 ft.** (54 m) tall and its massive base covers **45 acres** (18.2 ha).

ALPHABET CITY

*The North African nation of Egypt is another site of very large pyramids. Egypt is also the site of the **Earliest Alphabet.** Carvings of symbols used to represent single sounds, and dating back to 1900 B.C. were found near Luxor in Egypt by Egyptologist John Darnelll in the early 1990s.*

4:1 Take four school buses, stand them up end to end, and you'd have the height of this famous Maya temple.

TRUE OR FALSE: THE MAYA LOVED TO PLAY A GAME LIKE BASKETBALL.

True. Chichen Itza, the large city where Quetzalcóatl is located, also has a huge ball court, complete with hoops. They used human heads for balls!

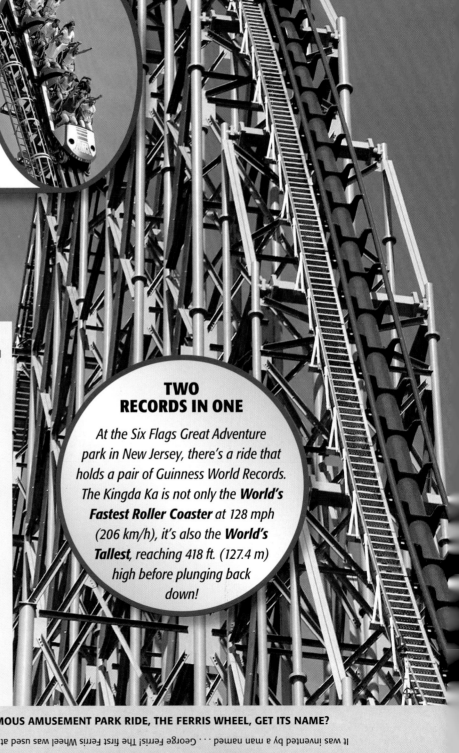

BETTER PLAN
A TWO-DAY TRIP

The **Amusement Park with the Most Rides** is Cedar Point Amusement Park in Ohio. It has 68 different mechanical rides (in 2005), the most of any similar park in the world! It was built in 1870 (but the rides aren't that old!).

A Long Ride!

If you ride the Steel Dragon 2000 at Nagashima Spaland in Japan, get ready to scream . . . for a long time! At **8,133 ft.** (2,479 m) the Steel Dragon is the **WORLD'S LONGEST ROLLER COASTER**. Round and round it goes, giving coaster fans an extra-long ride. At the top, the Dragon is **311 ft. 8 in.** (95 m) above the ground and at its fastest, it's going 92.5 mph (149 km/h).

TWO
RECORDS IN ONE

At the Six Flags Great Adventure park in New Jersey, there's a ride that holds a pair of Guinness World Records. The Kingda Ka is not only the **World's Fastest Roller Coaster** at 128 mph (206 km/h), it's also the **World's Tallest**, reaching 418 ft. (127.4 m) high before plunging back down!

HOW DID ANOTHER FAMOUS AMUSEMENT PARK RIDE, THE FERRIS WHEEL, GET ITS NAME?

It was invented by a man named . . . George Ferris! The first Ferris Wheel was used at a world's fair in Chicago in 1893.

NO, THE TRACK IS NOT CROOKED

It's "banked," that is, the roadway on most NASCAR tracks is tilted. In the corners, the outside edge is higher than the inside edge. This helps the heavy, fast-moving cars stick closer to the ground, making them easier to handle through the tricky curves.

NASCAR'S KING

*Seven-time NASCAR champ Richard Petty holds six records, including **Most NASCAR Race Victories in a Career** (200, 1958–1992) and **Most Wins in a NASCAR Season** (27 in 1967).*

Titanic Talladega

With a total length of **2.66 miles** (4.28 km), Talladega Superspeedway in Alabama is the **WORLD'S LARGEST NASCAR SPEEDWAY**.

NASCAR's finest drivers tackle this behemoth of a track twice each season, steering their 3,000 lbs. (1,360 kg) stock cars for hundreds of laps around Talladega.

The track was called the Alabama International Motor Speedway when it opened in 1969, when it was built for a total cost of $4 million.

In 1987, the track was the site of a famous NASCAR event. Driver Bill Elliott set a NASCAR mark by steering his bright orange Ford to a top speed of 212.809 mph (342.473 kph).

More than 143,000 people can be seated at Talladega to cheer on their favorites.

BUILDINGS AND LAND

RICHARD PETTY'S TOTAL OF SEVEN NASCAR CHAMPIONSHIPS WAS MATCHED BY WHAT OTHER DRIVER?

The late, great Dale Earnhardt, Sr, also won seven season titles.

81

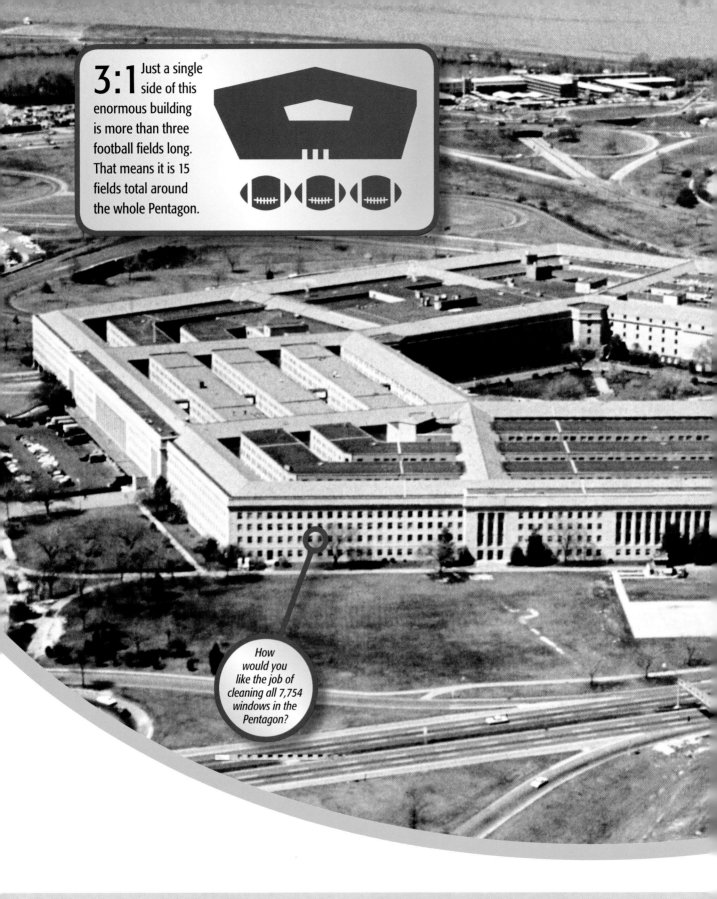

3:1 Just a single side of this enormous building is more than three football fields long. That means it is 15 fields total around the whole Pentagon.

How would you like the job of cleaning all 7,754 windows in the Pentagon?

CAN YOU NAME THE FOUR OFFICIAL BRANCHES OF THE UNITED STATES MILITARY?

The Army, the Navy, the Air Force, and the Marine Corps.

Gimme Five!

Five sides, that is, as in the five sides of what is perhaps the most unique and recognizable building in the United States. The Pentagon, named for its shape, of course, is the headquarters of the U.S. Department of Defense and many branches of the U.S. military. More than 26,000 people work in what is the **WORLD'S LARGEST ADMINISTRATIVE BUILDING**.

It has a floor area of **6.5 million sq. ft.** (604,000 sq m). The perimeter (outside edge) of the Pentagon is 4,610 ft. (1,405 m).

WORLD'S BIGGEST PALACE

*Taking up more than 178 acres (72 ha) in the center of Beijing, China, the Imperial Palace is the **World's Largest Palace**. Work on the enormous structure was begun by the third Ming Emperor, Yongle (1402–1424). Emperors following him added other buildings and halls to the grounds, so that it was centuries before it reached its current form. It is one of the most popular tourist attractions in China.*

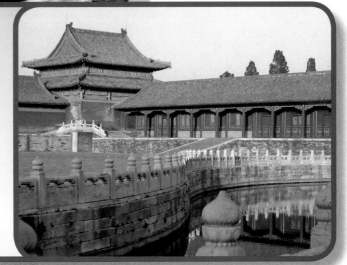

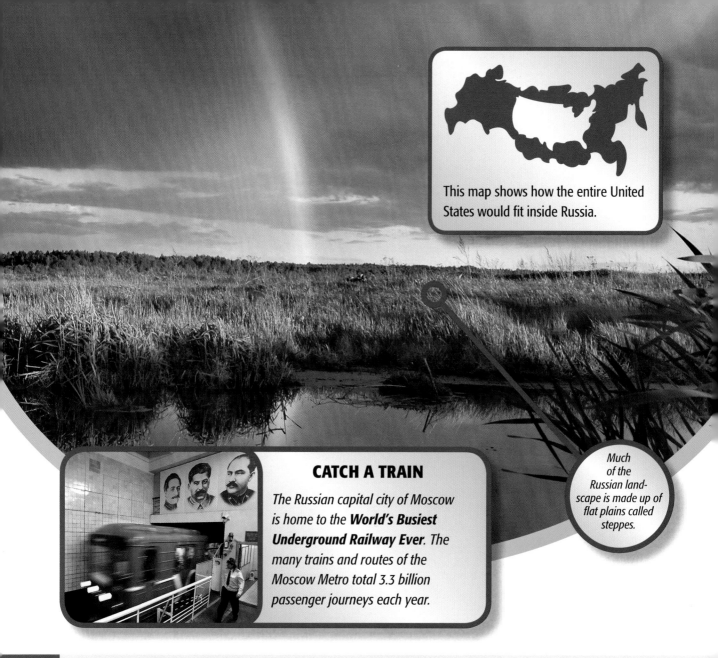

This map shows how the entire United States would fit inside Russia.

CATCH A TRAIN

*The Russian capital city of Moscow is home to the **World's Busiest Underground Railway Ever**. The many trains and routes of the Moscow Metro total 3.3 billion passenger journeys each year.*

Much of the Russian landscape is made up of flat plains called steppes.

Unbreakable Record?

Unless South America bands together to become one nation, or unless Africa decides to all live under one flag, Russia will retain the title of the **WORLD'S BIGGEST COUNTRY**.

Stretching from Eastern Europe to the Pacific Ocean (and including more than eight time zones), Russia's current land area is more than **6.5 million sq. miles** (17 million sq km). It takes up **11.5 percent** of the world's land area.

This humongous land is just full of world records. The Caspian Sea (which also touches four other nearby countries), with an area of **143,550 sq. miles** (371,800 sq km) is the **WORLD'S LARGEST LAKE**. Russia's Lake Baikal is the **WORLD'S DEEPEST LAKE**, with a depth of **5,371 ft.** (1,637 m).

FROM 1917 TO 1991, WHAT WAS THE NAME OF THE LARGER NATION THAT INCLUDED WHAT IS NOW RUSSIA?

Russia was the largest part of the Union of Soviet Socialist Republics (U.S.S.R.).

BIGGEST ISLAND

Surrounded by the North Atlantic Ocean, Greenland is the **World's Biggest Island** (not counting Australia, which is considered a continental land mass). Owned by Denmark, Greenland is nearly as big as the continental United States.

Pacific Power!

Seven-tenths of the surface of the Earth is covered by water. The Pacific Ocean is home to almost half of the water on the planet, making that enormous body of water the **WORLD'S BIGGEST OCEAN**.

The Pacific is so large that it touches six of the seven continents (Europe is the only exception). It covers about **63.186 million sq. miles** (166.241 million sq km). It is more than twice as big as the second-place Atlantic Ocean. The **DEEPEST POINT OF ANY OCEAN** is also found in the Pacific, in the Marianas Trench near the Philippines; it's **35,797 ft.** (10,911 m) deep.

The **Largest Paddle-in Wave Surfed** was 50 ft. (15.2 m) tall from trough to crest. Taylor Knox (not pictured) caught it off Ensenada, Mexico, on February 22, 1998.

VOCABULARY TIME: WHAT DOES "PACIFIC" MEAN?

Peaceful. The Pacific Ocean was named by the explorer Ferdinant Magellan, who first sailed into it in 1519.

85

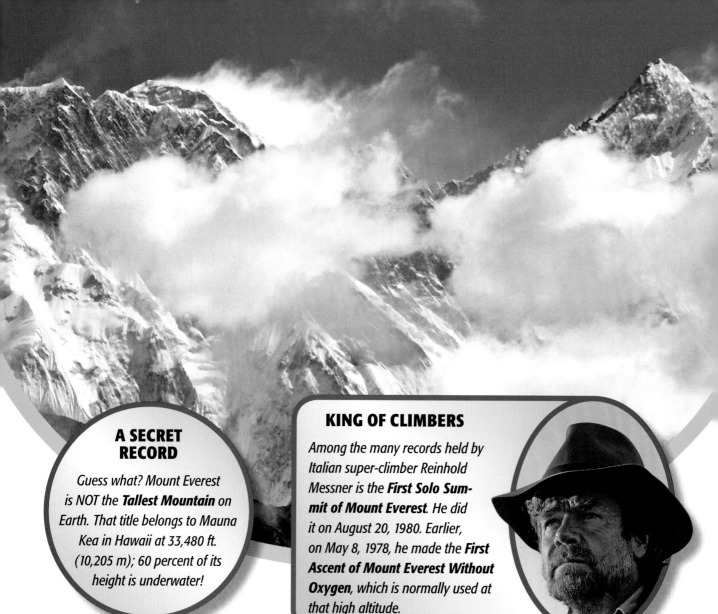

A SECRET RECORD

*Guess what? Mount Everest is NOT the **Tallest Mountain** on Earth. That title belongs to Mauna Kea in Hawaii at 33,480 ft. (10,205 m); 60 percent of its height is underwater!*

KING OF CLIMBERS

*Among the many records held by Italian super-climber Reinhold Messner is the **First Solo Summit of Mount Everest**. He did it on August 20, 1980. Earlier, on May 8, 1978, he made the **First Ascent of Mount Everest Without Oxygen**, which is normally used at that high altitude.*

A Mighty Mountain

It is perhaps one of the most famous places in the world, but only a small number of people have ever been there. It is revered as a holy place by the Sherpa people who live in its enormous shadow. It might be the home of a mysterious prehistoric creature, the Yeti. And it remained unconquered until 1953. What is it? It's Mount Everest in the Himalayas on the border between Nepal and Tibet.

We're talking about the **WORLD'S HIGHEST MOUNTAIN**.

Mount Everest stands **29,002 ft.** (8,840 m) above sea level. Covered with snow and ice year-round, it was named for a British surveyor named Col. George Everest.

The **FIRST ASCENT OF MOUNT EVEREST** was on May 29, 1953, by Sir Edmund Hillary and Sherpa Tenzing Norgay.

WHAT SOUTHERN ISLAND NATION WAS THE BIRTHPLACE OF SIR EDMUND HILLARY?

The famed mountain man was born in New Zealand.

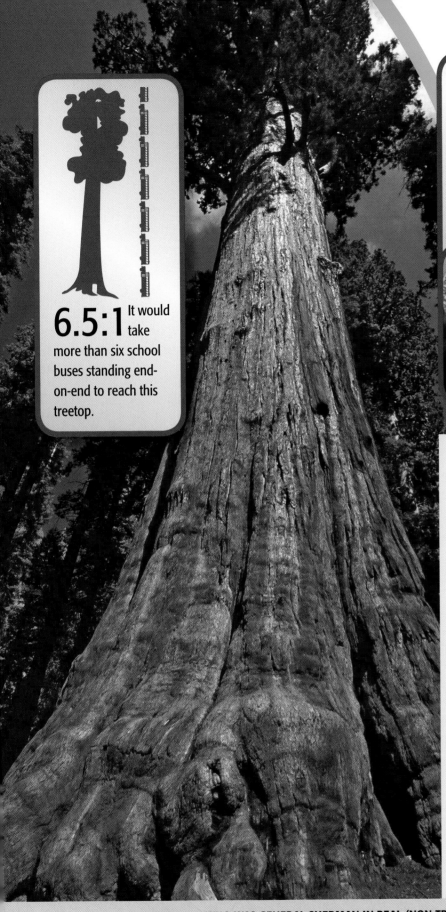

6.5:1 It would take more than six school buses standing end-on-end to reach this treetop.

BIG PLANT FAMILY

Plants, like other parts of the natural world, are divided into families. The family of plants with the most members is the orchid family. More than 25,000 different species of orchids grow nearly everywhere on Earth.

1, 2, Tree

Head to California, visit Sequoia National Park, and give a salute to the General—General Sherman, that is, which is the **WORLD'S LARGEST LIVING TREE**. The famous giant sequoia stands **271 ft.** (82.6 m) tall, and is **85 ft.** (25.9 m) in circumference! This mighty giant has enough wood in it to make 5 billion matchsticks, and it is thought to be 2,100 years old!

The Stratosphere Giant, a coast redwood, is the **WORLD'S TALLEST LIVING TREE**, and it is also in northern California. It stands **370 ft.** (112.7 m) tall!

WHO WAS GENERAL SHERMAN IN REAL (NON-TREE) LIFE?

General William Tecumseh Sherman was one of the Union Army's leaders during the Civil War.

Thar She Blows!

Volcanoes can be terrible and dangerous things. But they are also responsible for creating some beautiful places. For example, without volcanoes, we would not be able to vacation in the beautiful Hawaiian islands . . . because there would be no islands! The cooling lava formed the islands themselves.

It is on one of those volcanic islands (the "big island" of Hawaii itself) that you'll find a pair of record-setting volcanoes. The **WORLD'S LARGEST ACTIVE VOLCANO** is Mauna Loa, with its **75 mile** (120-km) long dome and **4 mile** (10.5-km) wide crater, while the **WORLD'S MOST ACTIVE VOLCANO** is Kilauea, also on the "Big Island," which has erupted continually since 1983!

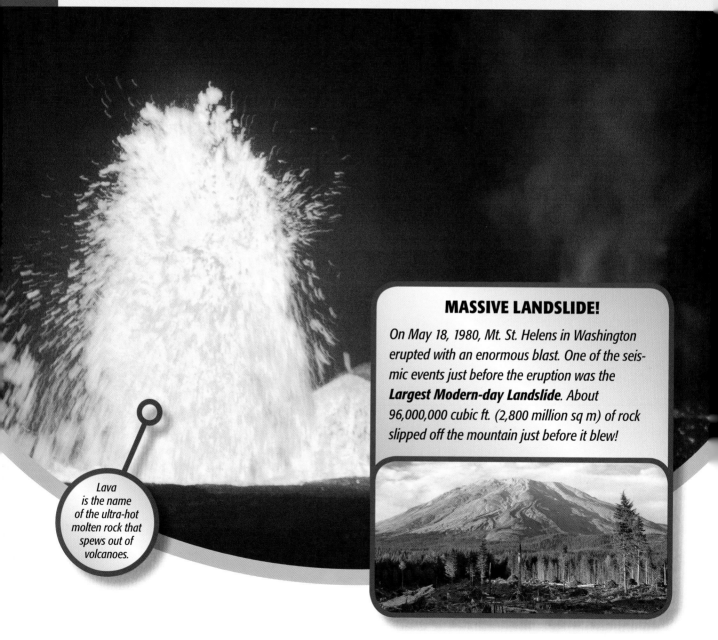

Lava is the name of the ultra-hot molten rock that spews out of volcanoes.

MASSIVE LANDSLIDE!

On May 18, 1980, Mt. St. Helens in Washington erupted with an enormous blast. One of the seismic events just before the eruption was the **Largest Modern-day Landslide**. About 96,000,000 cubic ft. (2,800 million sq m) of rock slipped off the mountain just before it blew!

HAWAII IS ONE OF THE SIX LARGEST HAWAIIAN ISLANDS. CAN YOU NAME THE OTHER FIVE MAJOR ONES?

Kauai, Lanai, Oahu, Molokai, and Maui

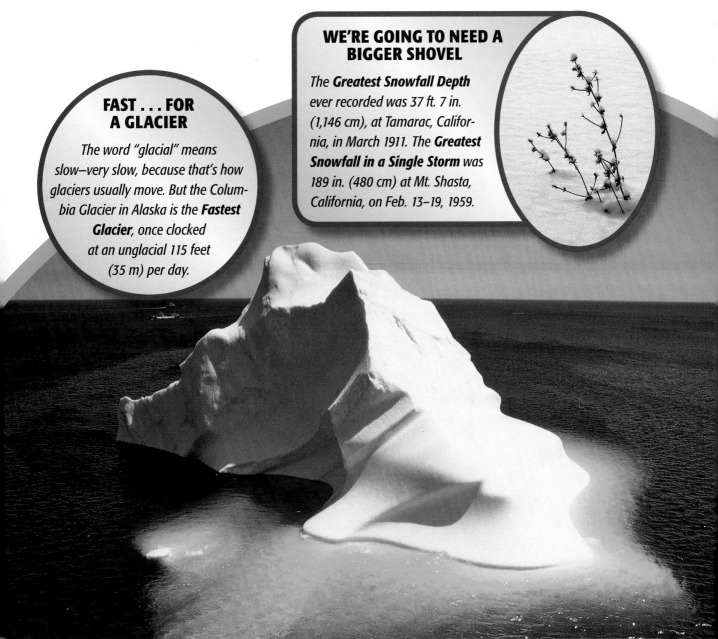

A Lot of Ice Cubes

Icebergs are pretty mysterious things. You might think that something as enor- mous as these giant floating blocks of ice would be easy to figure out. But the mystery is that most of the iceberg is underwater, out of view. That mystery is what makes them so dangerous to ships (just ask the *Titanic*, which struck one and sank in 1912). Scien- tists study and measure icebergs, and in 1957, Australian scientists discovered the Lambert Glacier, the **WORLD'S LONGEST GLACIER**.

That's not Lambert pictured above. As you'll see, you'd have to take a picture of the Lambert from a high-flying airplane. That's because the Lambert Iceberg is **40 miles** (64 km) wide and with its seaward extension is **440 miles** (700 km) long—that makes it lon- ger than the state of Florida!

GEOGRAPHY TIME: NAME THE SITES OF THE NORTH AND SOUTH POLES.

The South Pole is on the continent of Antarctica. The North Pole is in the Arctic Territory.

89

DOME, DOME ON THE GRASS!

The **Largest Dome Structure** in the world is the mighty Millennium Dome in London. Built to celebrate the year 2000, it has a diameter of 1,181 ft. (365 m) and its roof is 164 ft. (50 m) high. The yellow towers that support the roof are 312 ft. (95 m) tall.

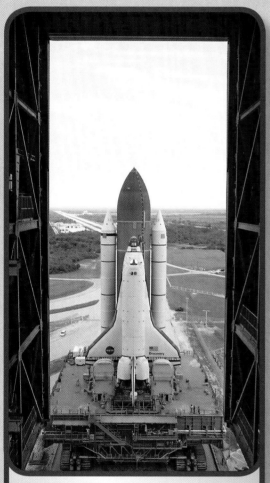

DON'T LOSE THE KEY!

The **Largest Doors** in the world are at the NASA Vehicle Assembly Building in Florida. They each stand 460 ft. (140 m), as high as a 35-story building!

FROG AND GATOR HEAVEN

Sprawling across Brazil is the Panatal, a vast area of rivers, lakes, and marsh that is the **World's Largest Swamp**. It covers 42,000 sq. miles (109,000 sq km), an area the size of Florida!

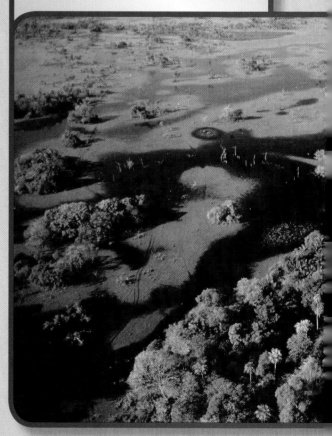

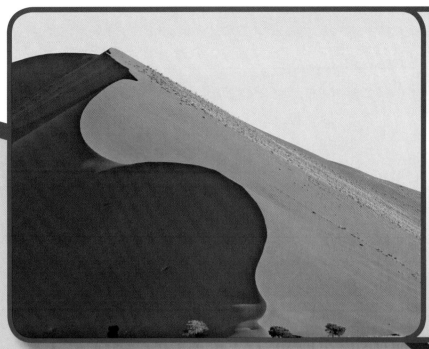

BIGGEST SANDBOX

As wide as the continental United States at 3,200 miles (5,150 km) and as wide as the Mississippi River is long at c. 1,200 miles (1,800 km), the Sahara Desert in North Africa is the **World's Largest Desert**. The vast area covered by the sand and scrub and mountains of the Sahara is an enormous 3,579,000 sq. miles (9,269,000 sq km).

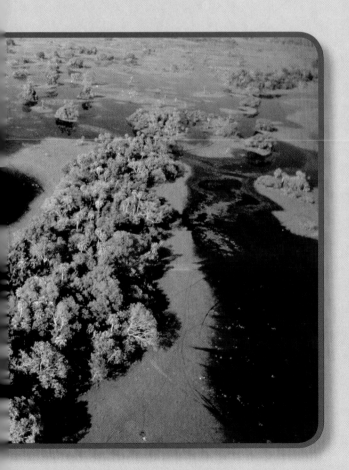

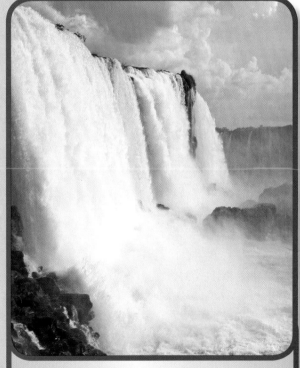

SPLISH, SPLASH!

The site of the **Greatest Waterfall Annual Flow** is the Boyoma Falls in Congo, with a flow of 600,000 cubic ft. (17,000 cubic m) per second!

Getting Around

Whether you drive, fly, ride, sail, skate, or blast off, you have to get around somehow! In this chapter, you'll see the BIGGEST, LARGEST, and TALLEST things from the world of transportation. Have your tickets ready . . . all aboard!

HEADING FOR A RIDE?

The United States spacecraft called the space shuttle rolls out onto the tarmac. It rides into space after becoming the Largest Object Transported by Air. See how on page 113.

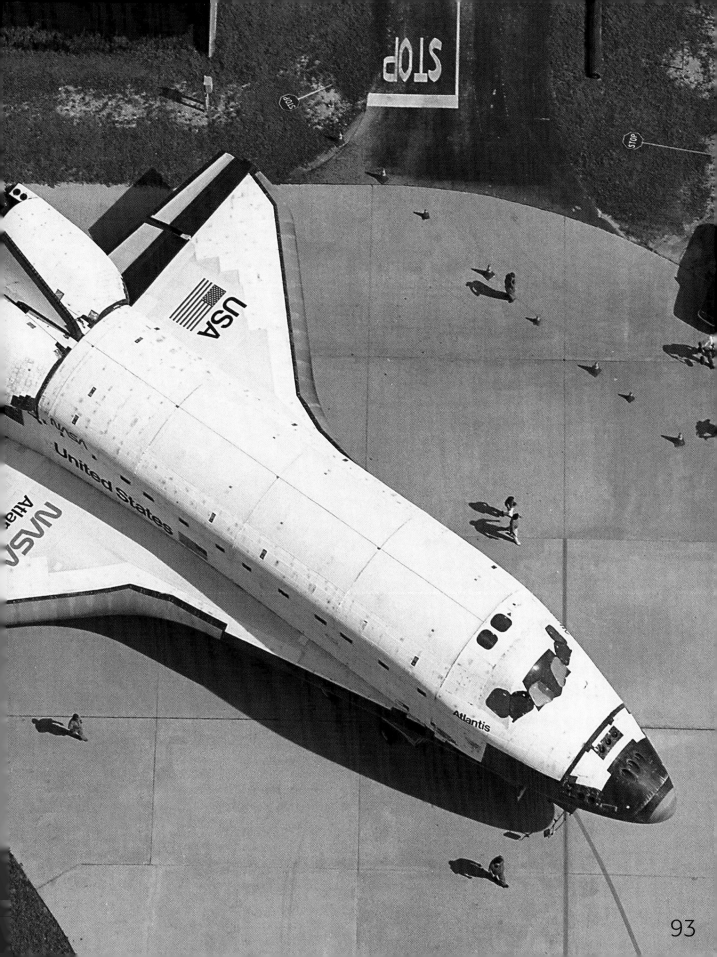

93

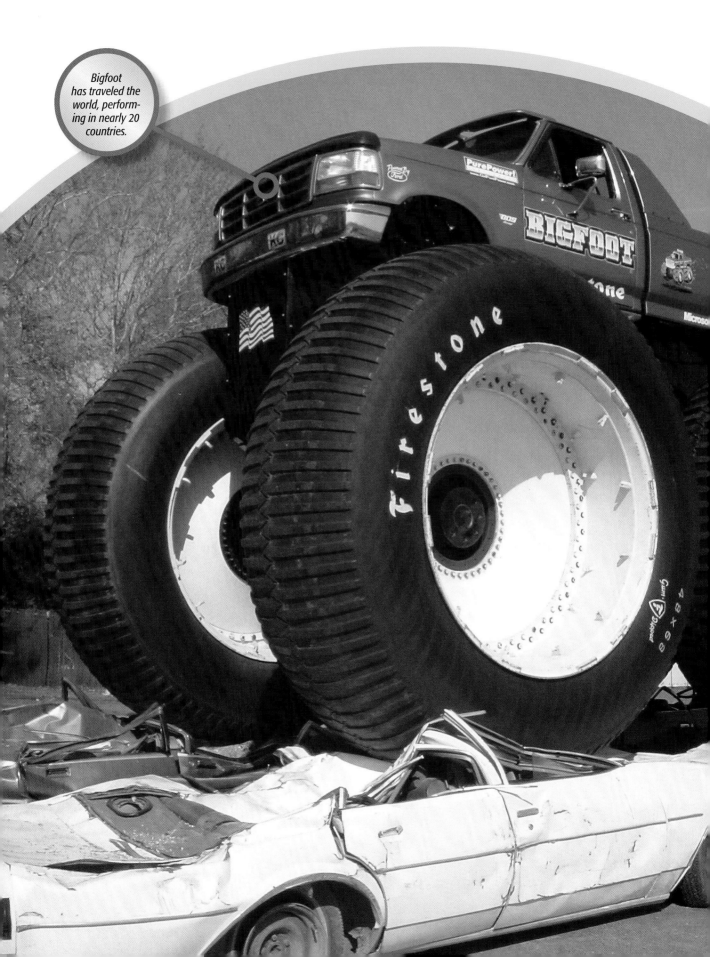

Bigfoot has traveled the world, performing in nearly 20 countries.

3:1 No matter how big your feet are, it would take you and two friends to equal Bigfoot's height.

Bigfoot Rules!

Did you ever wonder what it would be like to put **10 ft.** (3 m) tall tires on your dad's pickup? Well, Bob Chandler of St. Louis wondered the same thing, and in 1979, he debuted his first monster truck—a pickup truck with enormous wheels. As he crushed more and more cars with his truck, the tires just kept getting bigger. In 1986, he set a record that still stands. Bigfoot 5 is the **WORLD'S BIGGEST MONSTER TRUCK**! Bigfoot 5 stands **15 ft. 6 in.** (4.7 m) and weighs **38,000 lbs.** (17,326 kg). No, you can't borrow it for school.

The four tires on which Bigfoot rides are each 10 ft. (3 m) tall!

Firestone

48x68

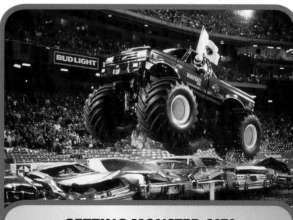

BUD LIGHT

GETTING MONSTER AIR!

On December 14, 1999, Bigfoot 14 (similar to the Bigfoot shown here), set a record for **Greatest Height Ramp Jump by a Monster Truck**. Dan Runte flew it to a height of 24 ft. (7.3 m). The landing was so hard one of the wheels snapped off!

BIGFOOT 14 SET A RECORD IN 1999 BY LEAPING OVER WHAT? A BUILDING, A ROAD, OR AN AIRPLANE?

In 1999, Dan Runte was behind the wheel as Bigfoot 14 drove up a ramp and flew over a 727 passenger jet—a distance of 202 ft. (61.57 m)!

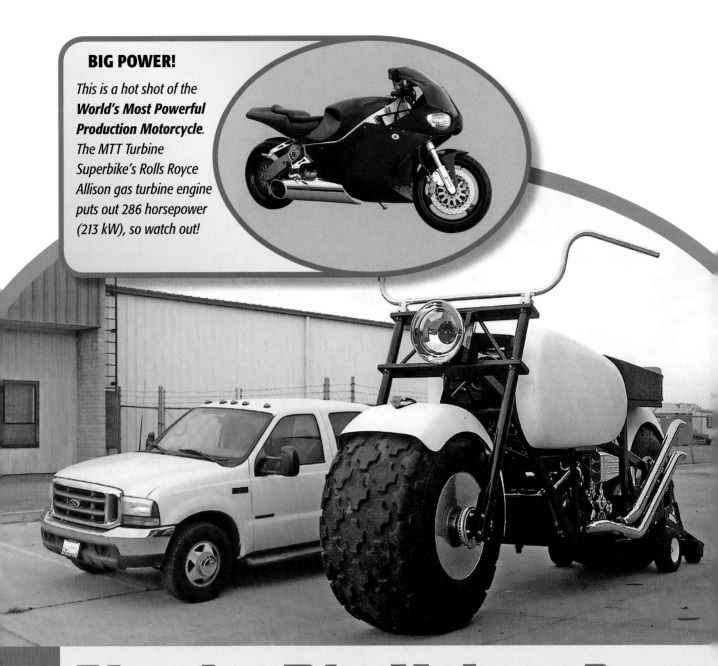

BIG POWER!

This is a hot shot of the **World's Most Powerful Production Motorcycle**. The MTT Turbine Superbike's Rolls Royce Allison gas turbine engine puts out 286 horsepower (213 kW), so watch out!

Need a Big Helmet?

What was Gregory Dunham thinking when he made this enormous vechicle, the **WORLD'S TALLEST RIDEABLE MOTORCYCLE**?

"Hey, maybe Hagrid from the Harry Potter books needs a motorcycle?"

Or, "I wonder what sort of motorcycle would sell well in the NBA?"

Or maybe he just read the plans through a magnifying glass and they expanded?

Whatever he was thinking, Dunham put together one monster machine. It measures **11 ft. 3 in.** (3.42 m) to the top of the handlebars. The "bike" is **20 ft. 4 in.** (6.18 m) long, and the whole thing weighs an incredible **6,500 lbs.** (2,948 kg).

Its engine is about the size of a NASCAR race car's, and it rides high above the street on tires that are nearly **6 ft.** (1.8 m) tall.

WHY IS MOTORCYCLE DAREDEVIL EVEL KNIEVEL IN THE GUINNESS WORLD RECORDS BOOK?

Evel set the record for Most Broken Bones in a lifetime, with 433 bone fractures. Ouch!

Big Garage Needed

You won't see many on the road these days, since they were first built in 1927 in Great Britain, but the Bugatti Royale type still remains the **WORLD'S LARGEST PRODUCTION CAR**. (By production, we mean it was regularly made for consumers; other one-of-a-kind cars have been bigger.) The "Golden Bugatti," as it's known, stretches **22 ft.** (6.7 m) in length. Just the hood alone is **7 ft.** (2.13 m) long. They're very valuable cars, too. In 1990, a 1931 version of the Bugatti Royale 41 Sports Coupe sold to a Japanese company for $15 million, becoming the most valuable car in the world!

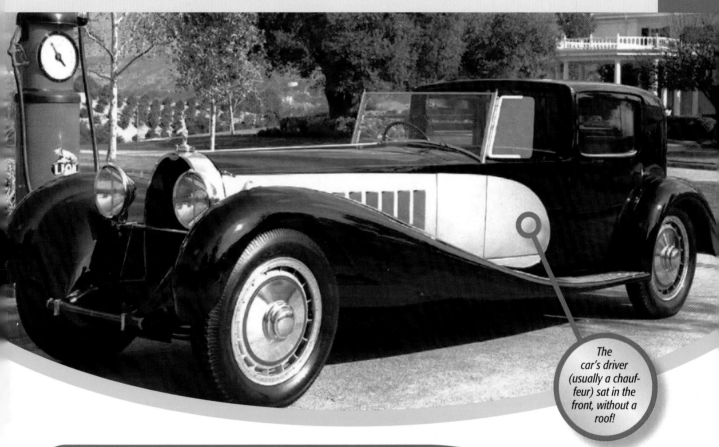

The car's driver (usually a chauffeur) sat in the front, without a roof!

CATCH IT IF YOU CAN

While the world's biggest car is about 80 years old, the title of **World's Fastest Production Car** has changed over time as engineers develop new engines. The current record-holder is the Koenigsegg CCR, which went 240.387 mph (387.866 km/h) in 2005.

IN 1999, SVEN-ERIC SODERMAN DROVE 214.7 MILES (345.6 KM) IN 10 HOURS, 38 MINUTES TO SET WHAT GUINNESS WORLD RECORD?

Sven-Eric set the record for **Side-Wheel Driving** by going the entire distance on only two side wheels of a four-wheeled car.

All Hail the Queen!

You've got rowboats, kayaks, ferries, and river boats. And then there is this monster. The *Queen Mary 2* is the **WORLD'S LARGEST PASSENGER LINER**.

The ship, built in England, is **1,132 ft.** (345 m) long and stands **236 ft.** (71 m) tall!

That's nearly as tall as a 25-story building!

A packed QM2 (as she's known) can hold **2,620 passengers** and **1,253 crew members**. It first set sail in 2005 after costing more than $800 million to build. And don't try to lift it: the QM2 weighs an incredible **151,400 tons**!

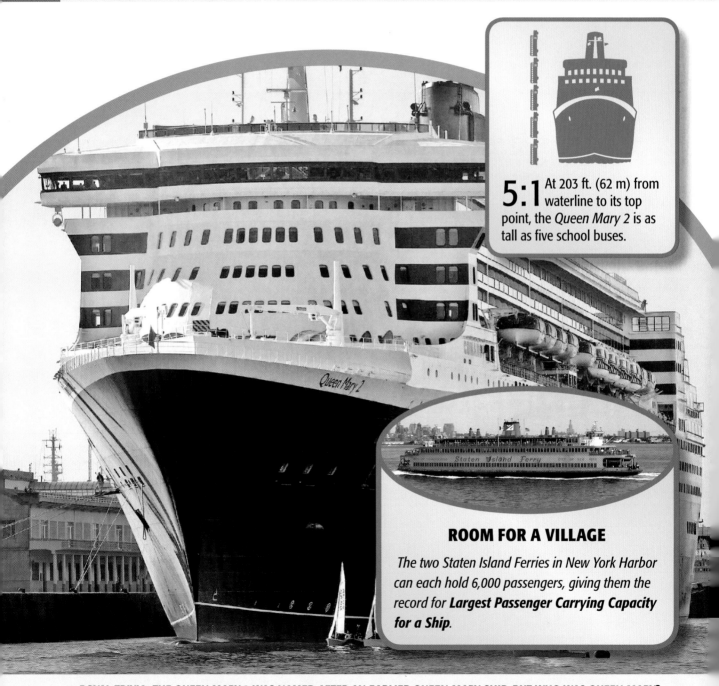

5:1 At 203 ft. (62 m) from waterline to its top point, the *Queen Mary 2* is as tall as five school buses.

ROOM FOR A VILLAGE

*The two Staten Island Ferries in New York Harbor can each hold 6,000 passengers, giving them the record for **Largest Passenger Carrying Capacity for a Ship**.*

ROYAL TRIVIA: THE QUEEN MARY 2 WAS NAMED AFTER AN EARLIER QUEEN MARY SHIP. BUT WHO WAS QUEEN MARY?

Queen Mary was the wife of Great Britain's King George V, who ruled until 1953.

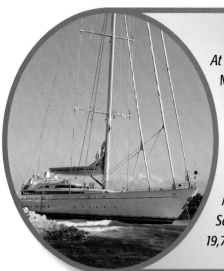

BIG SAIL HO!

At 246.7 ft. (75.2 m), the Mirabella V is the **World's Longest Sloop**. *It also has the* **World's Tallest Mast**, *at 295 ft. (90 m). It flies the* **World's Largest Sail** *as well. Made by Doyle Sailmakers, the sail is 19,730 sq. ft. (1,833 sq m).*

Rich Ship!

There's an old saying that goes, "It's good to be the king." One reason it's good to be a king is that you can afford to build and own the **WORLD'S LARGEST PRIVATE YACHT**. Stretching **482 ft.** (147 m) long and including a helicopter landing pad and several smaller boats on board, the *Abdul Aziz* was built in 1984 for $100 million. It was used by the Saudi Arabian royal family, especially the late King Fahd, and was named for one of the his sons.

5:1 Line up 5 football fields and you'll nearly equal the length of this amazing yacht.

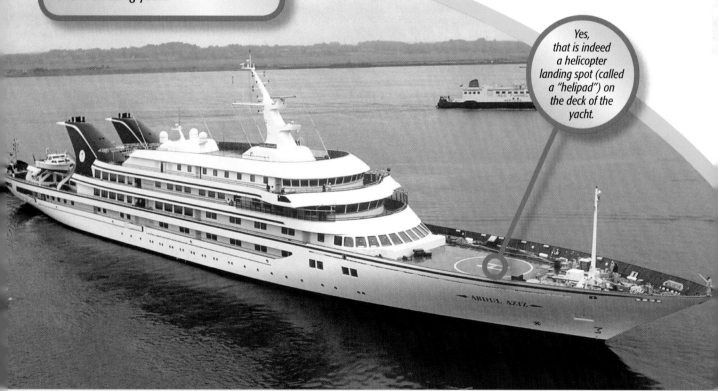

Yes, that is indeed a helicopter landing spot (called a "helipad") on the deck of the yacht.

A YACHT NEEDS A LOT OF POWER; WHAT SORT OF POWER IS THE COUNTRY OF SAUDI ARABIA BEST KNOWN FOR?

Saudi Arabia is the world's largest producer of oil.

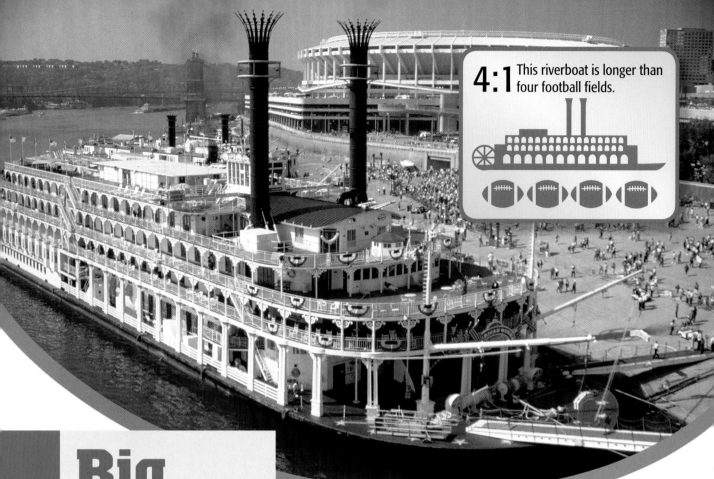

Big River!

During the second half of the 19th century, steamboats were found on rivers throughout America. But gasoline and diesel engines became much more popular and useful. Some steamboats remain, and fans enjoy the classic look of these river vessels. Along the Mississippi River, passengers can take a ride on the *American Queen*, the **WORLD'S LARGEST STEAMBOAT**. Launched in 1995, the boat measures **418 ft.** (127.4 m) long and weighs **4,891 tons**. It cost $65 million to build, and can carry 450 people.

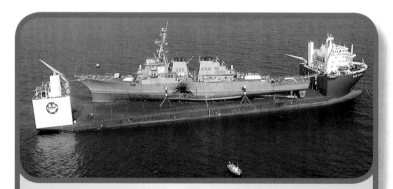

ONE BIG SHIP . . . TO GO

The **World's Largest Open-Deck Transport Ship** *is used to, well, transport ships. The* Blue Marlin *has a cargo deck 584 ft. 7 in.(178.2 m) long. It can actually sink 52 ft. 6 in. (16 m) to let whatever it's going to carry (a U.S. Navy ship here) float onto the deck!*

THE MISSISSIPPI IS AMERICA'S LONGEST RIVER; WHAT IS THE <u>WORLD'S LONGEST RIVER</u>?

The Nile River in Africa runs 4,160 miles (6,695 km) in length from Lake Victoria to the Mediterranean Sea.

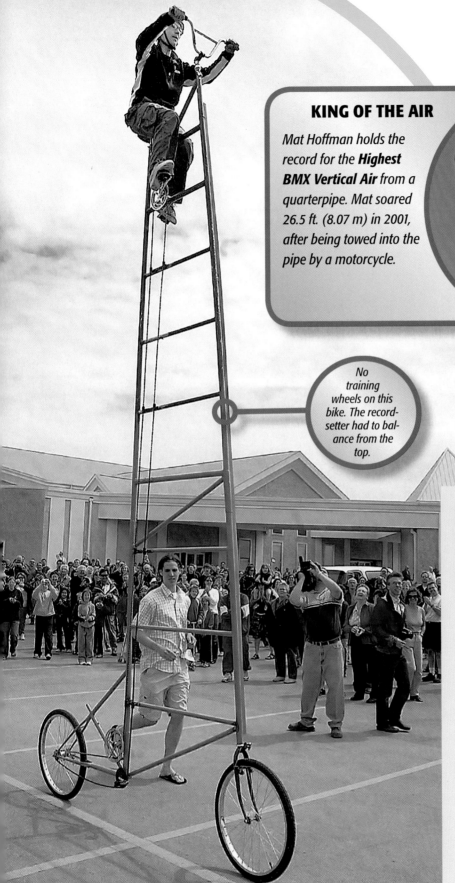

KING OF THE AIR

*Mat Hoffman holds the record for the **Highest BMX Vertical Air** from a quarterpipe. Mat soared 26.5 ft. (8.07 m) in 2001, after being towed into the pipe by a motorcycle.*

No training wheels on this bike. The record-setter had to balance from the top.

Nice View

Looking at this record-setting bicycle, you might have one question: What do you do when you stop? In 2004, Terry Goertzen solved that problem—and a few others—while riding **WORLD'S TALLEST RIDEABLE BICYCLE** for more than 1,000 ft. (300 m).

The bicycle towered **18 ft. 5 in.** (5.55 m) tall.

And stopping? Well, that's when Terry got some help!

A LITTLE BICYCLE HISTORY: WHAT DOES THE TERM "PENNY FARTHING" MEAN IN CYCLING?

One model of bicycle in the late 1800s had a huge front wheel, which reminded riders of a British coin of that name.

Ridin' in Style

You know you're riding in style—and several feet above the traffic around you—when you're taking a cruise on the streets in the **WORLD'S HIGHEST LIMOUSINE**.

Standing **10 ft. 11 in.** (3.33 m) from the ground to the roof, this monster-truck-tired limo was built in 2004 by Gary and Shirley Duval of Australia. It's a smooth ride, too, as each of the eight wheels has independent suspension. Two separate engines power this comfortable—and enormous—luxury automobile.

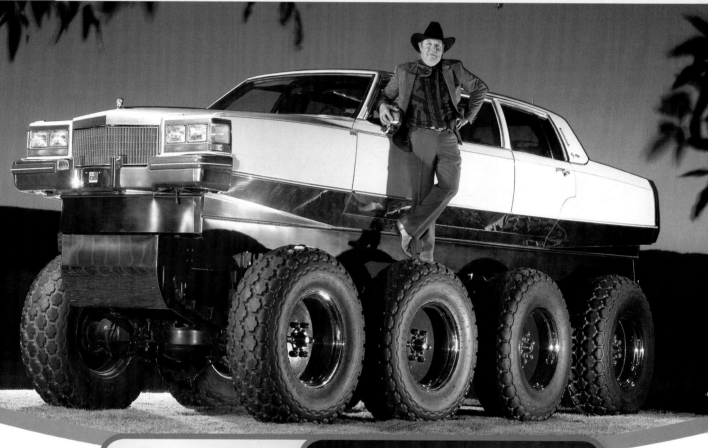

BIG HEADACHE?

*We'd tell you not to try this at home, but how could you? In 1999, strongman John Evans set the record for **Heaviest Car Balanced on the Head**. It's a small car—a Mini Cooper—but any car on your head is big! It weighed 352 lbs. (159.6 kg).*

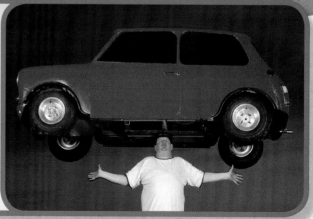

WHERE DOES THE WORLD "LIMOUSINE" COME FROM?

The residents of Limousin, France, wore hoods that were said to look like the front of early "stretch" cars.

Nice On Ice

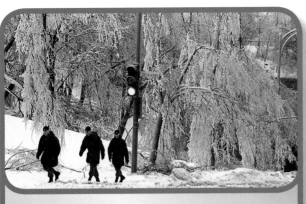

GET OUT YOUR SKATES

The **Worst Damage Toll from an Ice Storm** came in a storm that hit eastern Canada beginning January 6, 1998. More than 3 million people lost power after ice covered the land. The damages totaled $650 million.

The vast ice shelves and frozen seas of the North Pole have called to explorers for decades. The hardest part for most of them was fighting through the ice to reach the frozen land. They created special ships with thick, metal hulls that could crash through the ice to the sea beneath and allow passage. In 1969, the *SS Manhattan*, the **WORLD'S LARGEST ICEBREAKER**, made its debut in arctic Canada. Its steel armor was **9 ft.** (2.7 m) thick at the front (or bow). The entire ship was **1,007 ft.** (306.9 m) long and weighed **152,407 tons**.

Thick steel armor covered the first 670 feet (204 m) at the bow of the enormous ship.

MANHATTAN

THE LOWEST-EVER RECORDED TEMPERATURE ON EARTH WAS –128.6° F (–89.2° C). BUT WHERE?

In 1983, the temperature in Vostok, Antarctica, reached that bone-chilling mark.

Look! Up in the Sky!

If you and your entire school want to take a long field trip, now there is a way you can all travel together in style! The Airbus A380 can hold up to 555 people, making it the **WORLD'S LARGEST PASSENGER AIRPLANE**.

This massive metal bird made its debut in 2005 and will start flying regular trips in 2006. Here are some of the amazing numbers: the A380 is **239 ft. 6 in.** (73 m) long, nearly as long as a football field. Its wingspan (the distance from wing tip to wing tip) is even bigger than that, stretching **261 ft. 10 in.** (79.8 m).

Want to get to the cockpit? You'll need a pretty big ladder. The plane is **79 ft.** (24 m) tall, as big as an eight-story building.

Not surprisingly, it's pretty heavy, too, weighing **617,300 lbs.** (280,000 kg) when it's empty. Fill it with up to 500-plus passengers and all their bags and it's even more!

When the A380 starts flying, some airlines will use the huge space inside to set up on-board shops, bars, and lots of space to hang out. They'll need it, because the airplane can travel 8,000 miles (12,874 km) without stopping!

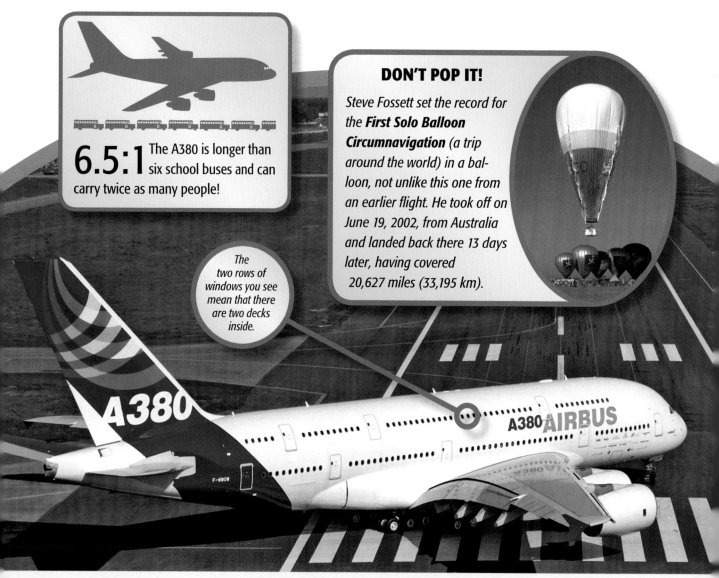

6.5:1 The A380 is longer than six school buses and can carry twice as many people!

The two rows of windows you see mean that there are two decks inside.

DON'T POP IT!

Steve Fossett set the record for the **First Solo Balloon Circumnavigation** (a trip around the world) in a balloon, not unlike this one from an earlier flight. He took off on June 19, 2002, from Australia and landed back there 13 days later, having covered 20,627 miles (33,195 km).

A380

A380 AIRBUS

THE A380 IS MADE BY AIRBUS; IN WHAT COUNTRY IS AIRBUS HEADQUARTERED—ENGLAND, FRANCE, OR RUSSIA?

Airbus is an enormous company located in France!

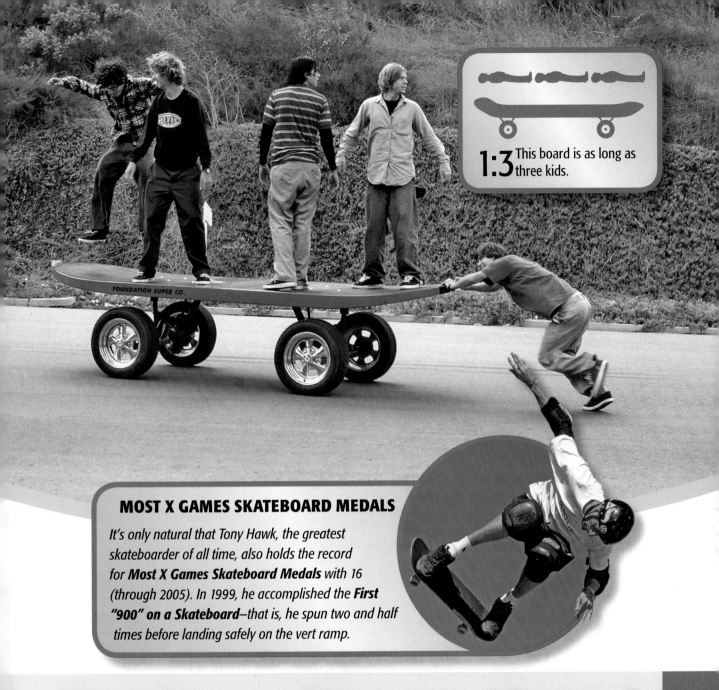

1:3 This board is as long as three kids.

MOST X GAMES SKATEBOARD MEDALS

*It's only natural that Tony Hawk, the greatest skateboarder of all time, also holds the record for **Most X Games Skateboard Medals** with 16 (through 2005). In 1999, he accomplished the **First "900" on a Skateboard**–that is, he spun two and half times before landing safely on the vert ramp.*

Dude . . . That's Huge!

Think you're a good skateboarder? Let's see you try to do an ollie on this big boy.

The **WORLD'S LARGEST SKATEBOARD** was built in San Diego by Tod Swank, Greg Winter, Dana Hard, and Damon Mills of Foundation Skateboards WBS. The deck measures **12 ft.** (3.66 m) long and is **4 ft.** (1.2 m) wide. Want to toss it in your backpack to take to school? No problem, as long as you can lift **500 lbs.** (200 kg). To get on top, you have to climb **2 ft. 6 in.** (.76 m), and the whole enormous thing rides on car tires. As the picture above shows, even the guys who built this gigantic board need some help getting started. How do you stop? Just jump off . . . onto something soft!

GETTING AROUND

WHAT TECHNOLOGICAL INNOVATION REVOLUTIONIZED SKATEBOARDING IN 1973?

Frank Nasworthy created polyurethane wheels, which made new tricks possible. Earlier wheels had been made of clay or hard rubber.

Holy Moto!

Moto X is one of the highest-flying, engine-racing, thrillseeking events at the X Games. Racers on specially-equipped motorcycles leap from ramps and perform daring mid-air tricks, sometimes letting go of the bike entirely. The biggest superstar of the sport so far has been Brian Deegan. With nine X Games medals, including two gold medals, he holds the record for **MOST MOTO X MEDALS WON BY AN INDIVIDUAL** at the X Games. Nebraska native Brian first got into motorcycles as a dirt-track racer. He started inventing his own tricks and became a pioneer of the now-famous Moto X style.

ON THE ROAD AGAIN

*Since 1911, motorcycle races have been held on the "Mountain" circuit on the Isle of Man (UK). At 37.73 miles (60.72 km), this 264-curve test of skill is the **World's Longest Motorcycle Race Circuit**.*

An extreme-sports competition that includes skateboarding and stunt bike riding.

High Flyer

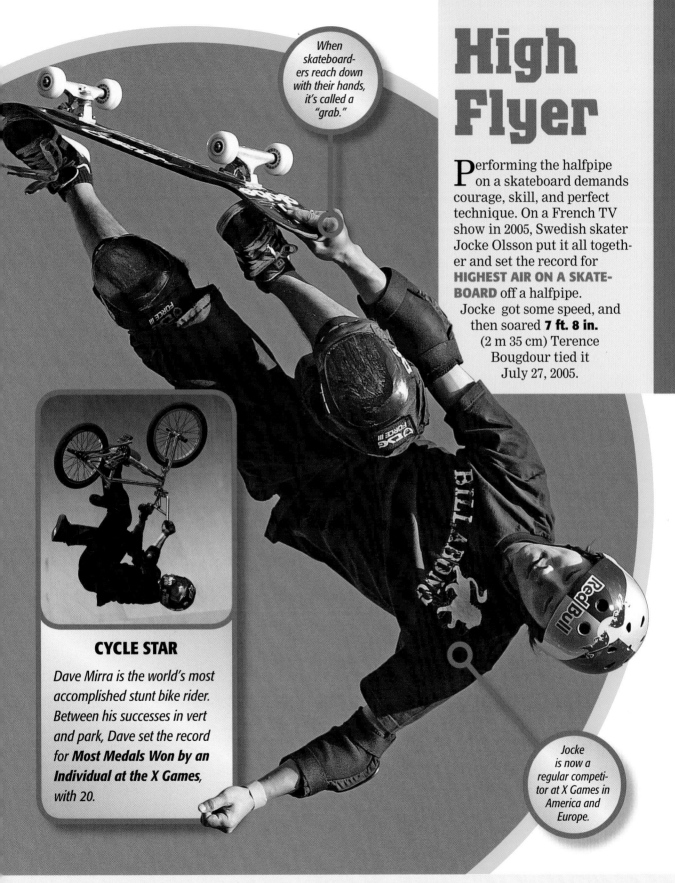

When skateboarders reach down with their hands, it's called a "grab."

Performing the halfpipe on a skateboard demands courage, skill, and perfect technique. On a French TV show in 2005, Swedish skater Jocke Olsson put it all together and set the record for **HIGHEST AIR ON A SKATEBOARD** off a halfpipe. Jocke got some speed, and then soared **7 ft. 8 in.** (2 m 35 cm) Terence Bougdour tied it July 27, 2005.

CYCLE STAR

Dave Mirra is the world's most accomplished stunt bike rider. Between his successes in vert and park, Dave set the record for *Most Medals Won by an Individual at the X Games,* with 20.

Jocke is now a regular competitor at X Games in America and Europe.

IN SKATEBOARDING, WHAT IS AN "OLLIE"?

It is a trick in which the rider kicks the back of the board down to make the entire board lift off the ground.

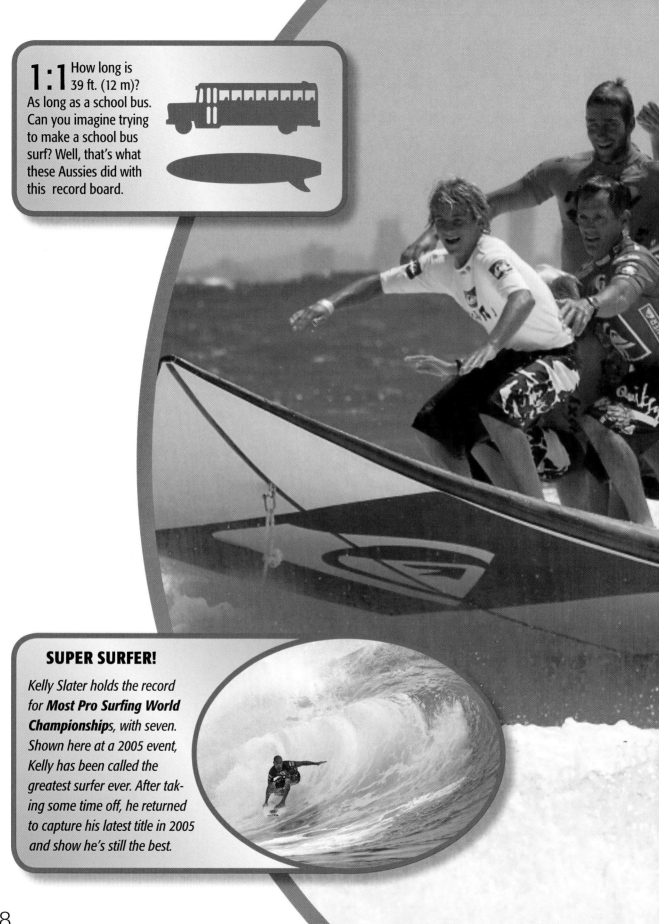

1:1 How long is 39 ft. (12 m)? As long as a school bus. Can you imagine trying to make a school bus surf? Well, that's what these Aussies did with this record board.

SUPER SURFER!

*Kelly Slater holds the record for **Most Pro Surfing World Championships**, with seven. Shown here at a 2005 event, Kelly has been called the greatest surfer ever. After taking some time off, he returned to capture his latest title in 2005 and show he's still the best.*

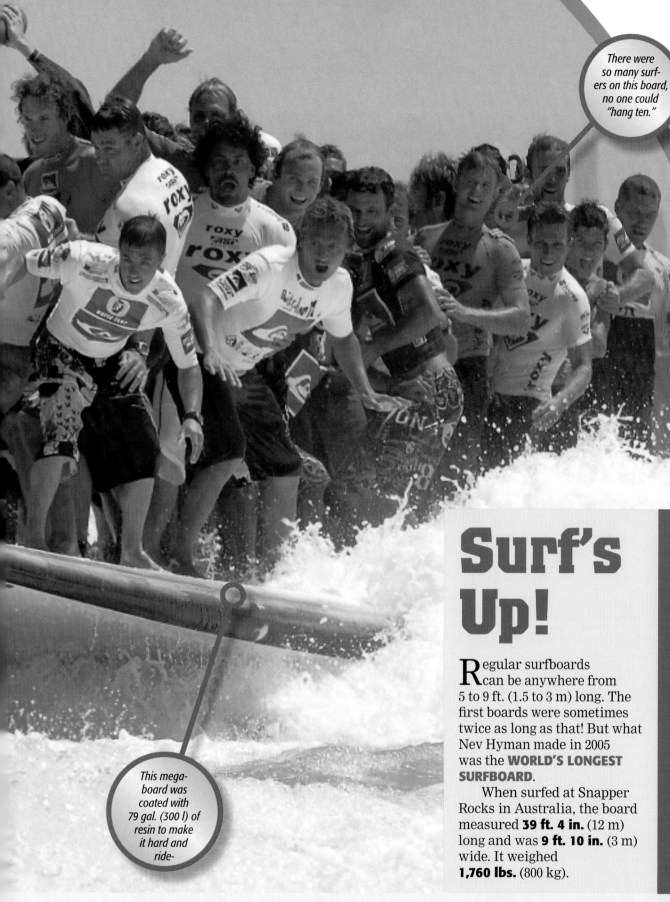

There were so many surfers on this board, no one could "hang ten."

This mega-board was coated with 79 gal. (300 l) of resin to make it hard and ride-

Surf's Up!

Regular surfboards can be anywhere from 5 to 9 ft. (1.5 to 3 m) long. The first boards were sometimes twice as long as that! But what Nev Hyman made in 2005 was the **WORLD'S LONGEST SURFBOARD**.

When surfed at Snapper Rocks in Australia, the board measured **39 ft. 4 in.** (12 m) long and was **9 ft. 10 in.** (3 m) wide. It weighed **1,760 lbs.** (800 kg).

A SURFER CATCHES A WAVE AND THEN WIPES OUT. IS A WIPE OUT GOOD OR BAD?

A wipe out in surfing is usually bad; it means a surfer has fallen off his board!

Plenty of Pickup

The most popular vehicle in America for each of the past five years has been a pickup truck. But all those pickup fans would have to move aside if they saw this truck coming up in their rear-view mirrors. At **21 ft. 6 in.** (6.55 m) long, and weighing **14,500 lbs.** (6,577 kg), this ITEC 7300 CXT is the **WORLD'S LARGEST PRODUCTION PICKUP TRUCK**.

It stands **9 ft.** (2.74 m) tall, but even though it's a rolling giant, a person with a regular drivers' license can take it out on the road.

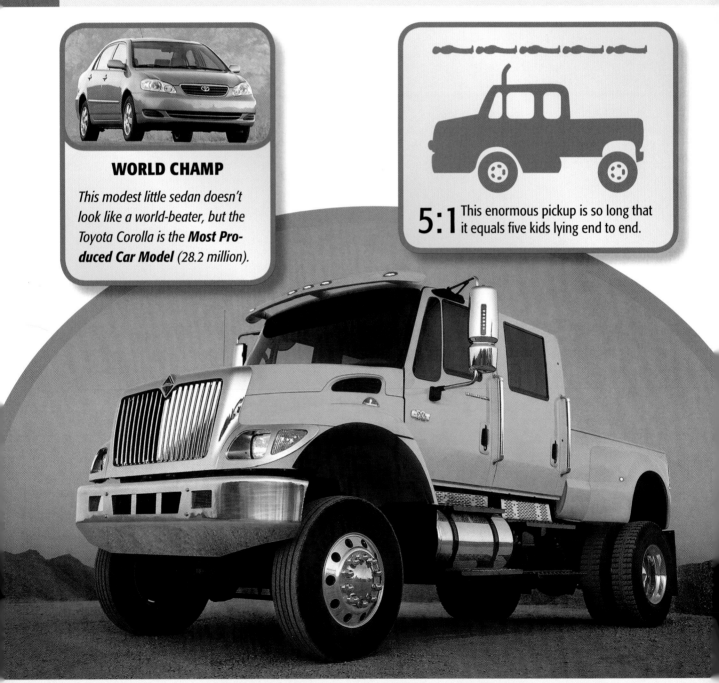

WORLD CHAMP

*This modest little sedan doesn't look like a world-beater, but the Toyota Corolla is the **Most Produced Car Model** (28.2 million).*

5:1 This enormous pickup is so long that it equals five kids lying end to end.

AUTO DETAIL TRIVIA TIME: WHAT IS THE BED OF A PICKUP TRUCK?

The flat area behind the cab (or passenger section) is called the bed.

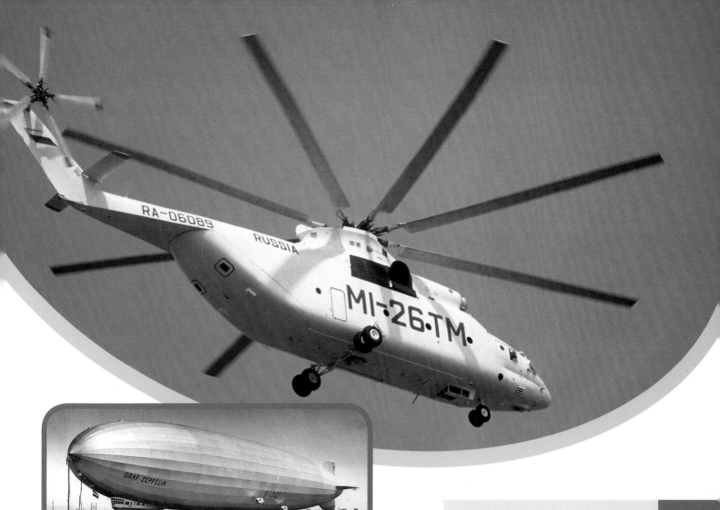

RA-06089
RUSSIA
MI-26-TM

WAAAY BIGGER THAN A BLIMP

*If this Graf Zeppelin II or its twin, the Hindenburg, showed up over a football game, they would dwarf the stadium. The **World's Largest Airships** were 803 ft. 10 in. (245 m) when they flew before World War II.*

3:1 At 131 ft. (40 m) long, the Mi-26 is longer than three school buses.

Big Blades

Remember the yacht back on page 99? Well, there's no way that this aircraft, the **WORLD'S LARGEST PRODUCTION HELICOPTER**, would be able to land on that ship's helicopter deck. Even the world's tallest hotel (page 75) couldn't handle the **105-ft.** (32 m) diameter of this Mil Mi-26 chopper. Made in Russia and handled by an expert crew of five, the Mi-26 can lift off weighing **123,460 lbs.** (56,000 kg).

GETTING AROUND

THE HELICOPTER WAS DEVELOPED IN THE 1930S. WHAT FAMOUS ITALIAN SUGGESTED A HELICOPTER IN THE 1500S!

The inventor, artist, and scientist Leonardo da Vinci sketched out plans for a helicopter way back then!

Big Rocket: V, 4, 3, 2, 1

The space shuttle (see box below) is today's most-used space vehicle, but in the 1960s, NASA sent astronauts to the moon via this gigantic rocket. The Saturn V was the **WORLD'S LARGEST ROCKET**. They rode in a tiny capsule atop this **363 ft.** (110.6 m) high rocket. It had three stages, most of which were filled with fuel. As the fuel burned off, the stages separated, falling harmlessly back to Earth. The remaining sections continued their journey. The Saturn V made 13 journeys to space.

At liftoff, the Saturn V weighed an incredible **7.6 million lbs.** (3.4 million kg)!

The orange metal tower held the rocket upright until liftoff, plus let workers and astronauts reach the rocket, via elevators.

9:1 Though they'd never make it to space, it would take nine buses to match this rocket's height.

Three astronauts rode in a capsule located here, in the nosecone of the rocket.

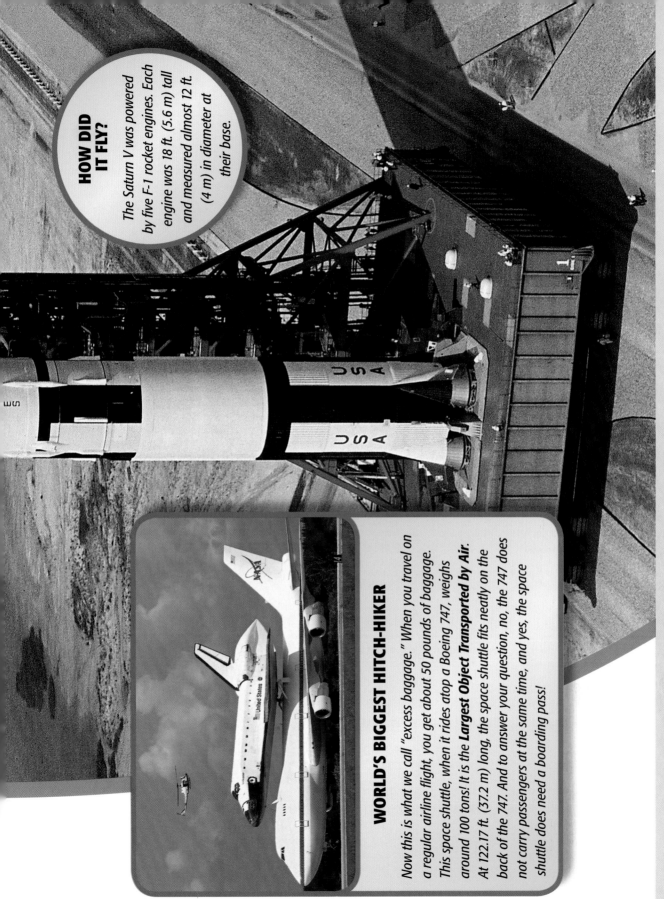

HOW DID IT FLY?

The Saturn V was powered by five F-1 rocket engines. Each engine was 18 ft. (5.6 m) tall and measured almost 12 ft. (4 m) in diameter at their base.

WORLD'S BIGGEST HITCH-HIKER

*Now this is what we call "excess baggage." When you travel on a regular airline flight, you get about 50 pounds of baggage. This space shuttle, when it rides atop a Boeing 747, weighs around 100 tons! It is the **Largest Object Transported by Air**. At 122.17 ft. (37.2 m) long, the space shuttle fits neatly on the back of the 747. And to answer your question, no, the 747 does not carry passengers at the same time, and yes, the space shuttle does need a boarding pass!*

AFTER RIDING A SATURN V ROCKET, NEIL ARMSTRONG BECAME THE FIRST MAN ON THE MOON. WHO WAS THE SECOND?

Following Armstrong to the moon's surface was Edwin "Buzz" Aldrin.

CASHING IN

Jeff Gordon (No. 24) has the **Highest Career Earnings in NASCAR**. Through 2005, Jeff, a four-time series champion, had won $66,956,249 in prize money.

A RECORD CUSHION OF AIR

*A hovercraft is a mighty machine that floats on the ocean on a cushion of air. Huge blowers fill black rubber tubes and then fans at the back of the boat push it forward. The **Largest Civilian Hovercraft** ever was the SRN4 Mk III, which carried passengers across the English Channel until 2000.*

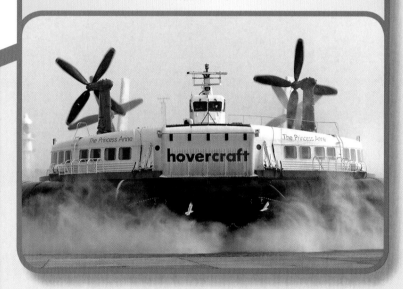

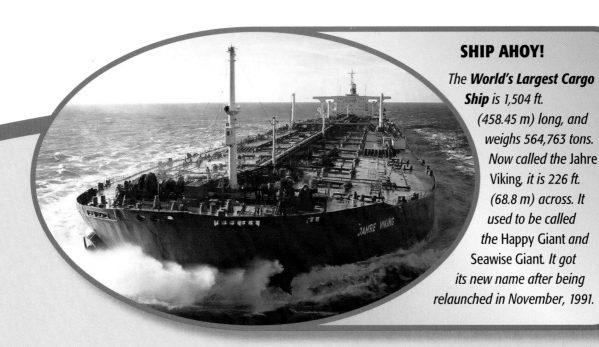

SHIP AHOY!

The **World's Largest Cargo Ship** is 1,504 ft. (458.45 m) long, and weighs 564,763 tons. Now called the Jahre Viking, it is 226 ft. (68.8 m) across. It used to be called the Happy Giant and Seawise Giant. It got its new name after being relaunched in November, 1991.

TREMENDOUS TRAIN

If you have to wait for the **Longest Freight Train** at a crossing, we hope you have this book to read! In 2001, a 682-car, 4.568 mi. (7.353 km) train (like this one) traveled 171 mi. (275 km) in Australia.

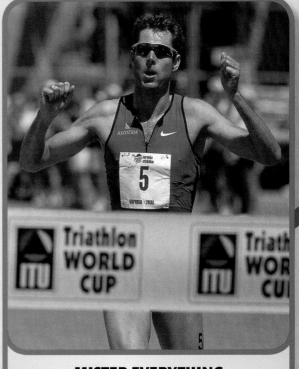

MISTER EVERYTHING

Triathlons, a swimming-biking-running race, are the ultimate sports test of this chapter's theme of "getting around." With four titles, Great Britain's Simon Lessing has won **Most World Triathlon Championships**.

Grab Bag

This book is about "everything," and we couldn't cover it all in the previous five chapters. So in this chapter, you'll find all the stuff that didn't fit somewhere else! Have fun grabbing in Grab Bag!

LOOK! UP IN THE SKY!

Go fly a kite! Well, if you wanted to fly this record-setter, you'd need a whole heck of a lot of friends to help you hold it (see page 124).

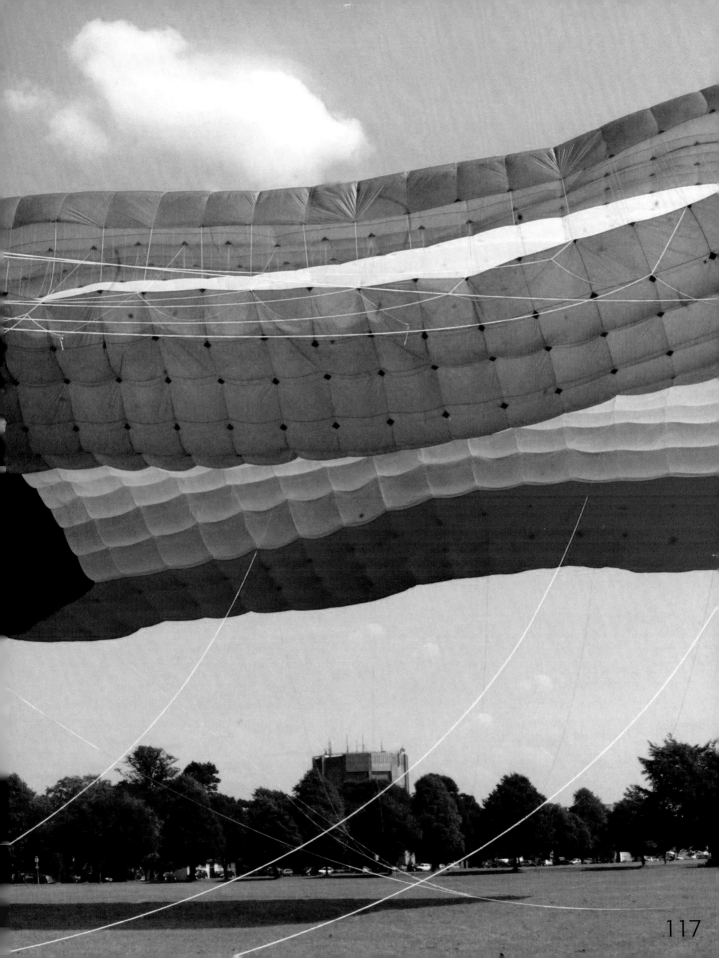

Snap, Snap!

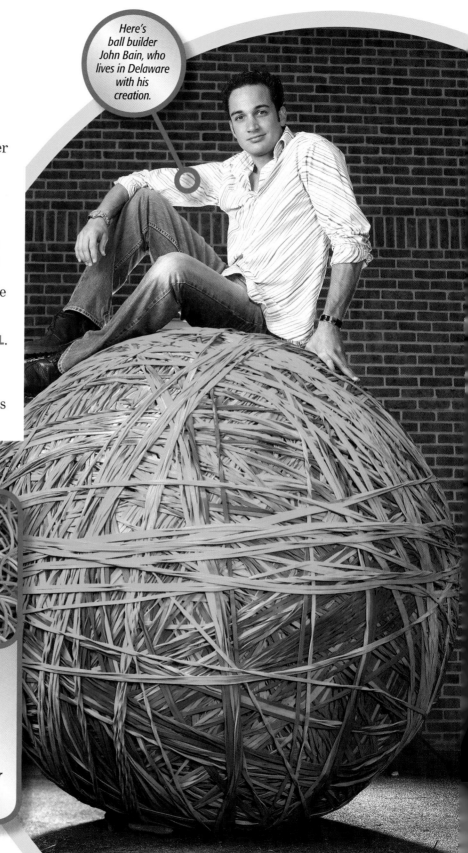

Do you have a junk drawer in your home? Lots of people do; it's where the little stuff that doesn't seem to have a place somewhere else ends up. Usually, there are a bunch of rubber bands in there. John Bain saw this situation and saw an opportunity. In 2003, he made it come true when he finished the **WORLD'S LARGEST RUBBER BAND BALL**. No junk drawer we know would hold this bouncy behemoth. It weighed **3,210 lbs.** (1,415.2 kg) and was **15 ft. 1 in.** (4.59 m) around!

MAKE YOUR OWN

Every record-setting rubber band ball starts small. Try making your own giant ball. Just get a lot of rubber bands and start putting them around and around a center of balled-up bands.

WHERE DOES RUBBER COME FROM: TREES, ROCKS, OR THE OCEAN?

Most rubber is created by using materials from different types of plants.

Lotta Paint

In 1977, Michael and Glenda Carmichael started painting a baseball . . . with two coats of paint a day. And they just didn't stop. Their dedication to their passion has led them to set a record for the **MOST LAYERS OF PAINT ON A BALL**. The result is a ball that is **9 ft. 1 in.** (2.77 m) around. So how do we know how many layers of paint there are? The Carmichaels took a core sample and did some serious counting. They counted 17,994 layers of paint.

GRAB BAG

WHO IS ROY G. BIV?

That name is used to help remember the order of colors in the rainbow: red, orange, yellow, green, blue, indigo, and violet.

119

String It Along

This "record" comes with a bit of controversy. Surprisingly, building the **WORLD'S LARGEST BALL OF STRING** has fascinated many people. You might see many giant balls of string or twine called the "biggest," but only one has been submitted and approved for official measurement as a Guinness World Record.

That record holder is the ball of string that measured **41 ft. 6 in.** (12.65 m) in circumference, tied by J. C. Payne.

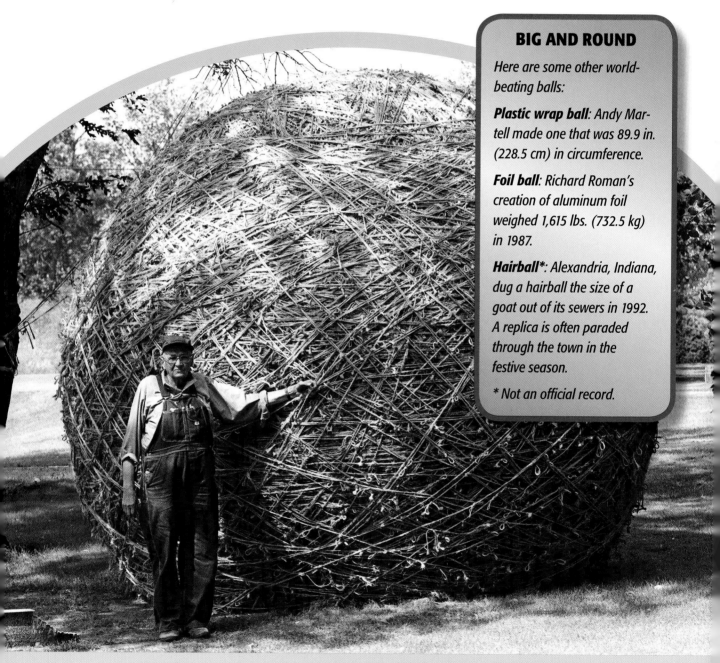

BIG AND ROUND

Here are some other world-beating balls:

Plastic wrap ball: Andy Martell made one that was 89.9 in. (228.5 cm) in circumference.

Foil ball: Richard Roman's creation of aluminum foil weighed 1,615 lbs. (732.5 kg) in 1987.

Hairball*: Alexandria, Indiana, dug a hairball the size of a goat out of its sewers in 1992. A replica is often paraded through the town in the festive season.

* Not an official record.

THE EARTH, OF COURSE, IS A BIG BALL, TOO. HOW BIG IS IT AROUND THE CIRCUMFERENCE?

The circumference of the Earth is about 24,900 miles (40,000 km).

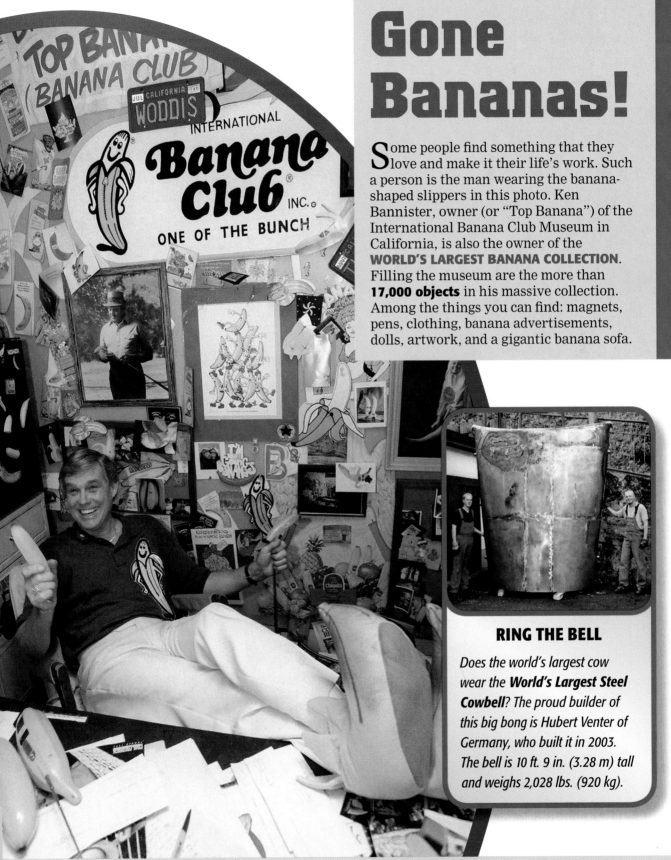

Gone Bananas!

Some people find something that they love and make it their life's work. Such a person is the man wearing the banana-shaped slippers in this photo. Ken Bannister, owner (or "Top Banana") of the International Banana Club Museum in California, is also the owner of the **WORLD'S LARGEST BANANA COLLECTION**. Filling the museum are the more than **17,000 objects** in his massive collection. Among the things you can find: magnets, pens, clothing, banana advertisements, dolls, artwork, and a gigantic banana sofa.

RING THE BELL

Does the world's largest cow wear the **World's Largest Steel Cowbell**? The proud builder of this big bong is Hubert Venter of Germany, who built it in 2003. The bell is 10 ft. 9 in. (3.28 m) tall and weighs 2,028 lbs. (920 kg).

BANANAS ARE A GOOD SOURCE OF WHAT IMPORTANT NUTRIENT?

Bananas supply potassium.

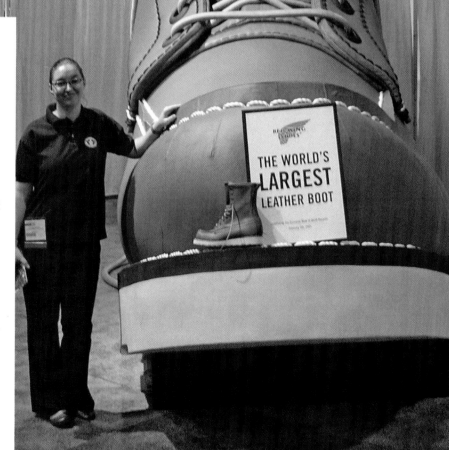

YEEE-HA!

*These are the **World's Largest Cowboy Boots**. They were made in 1999 by Rocketbuster Boots. The boots are 4 ft. 6.75 in. (1.38 m) tall and weigh about 100 lbs. (45 kg).*

This gigantic boot would fit a person who wears size 638 1/2 shoes.

A Big Boot!

Raise your hand (or your foot) if you have heard your mom yell at you to "Pick up your shoes!" Well, just be glad that one of these mighty boots is not what you leave lying around the house . . . or else you'd need a forklift! In 2005, the Red Wing Shoe Company of Minnesota created the **WORLD'S LARGEST BOOT**. Made of more than 80 cowhides, the really big boot is **20 ft.** (6 m) long, **7 ft.** (2.1 m) wide, and stands a mighty **16 ft.** (4.8 m) tall. The laces are **109 ft.** (33.2 m) long! Good luck tying it!

WHY ARE THE TOES OF COWBOY BOOTS SO POINTED?

The toes are pointed to help busy cowboys slip their boots into their stirrups while riding.

Super Sandal

Judging by the kid standing inside this massive sandal, he's probably going to have to ask for another size. This enormous example of the cobbler's art is the **WORLD'S LARGEST SANDAL**. It was made in December, 2003, by Nelson Jimenez Florez on behalf of the Diseños Ruddy store in Colombia.

The stupendous sandal is a stunning **21 ft. 7 in.** (6.6 m) long. It is also **6 ft. 6 in.** (2 m) wide, and stands **11 ft. 5 in.** (3.5 m) high.

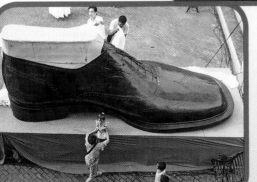

A REALLY BIG SHOE

Unveiled in 2002 in Marikina City in the Philippines, this is the **World's Largest Shoe**. And no, it doesn't fit anyone. It's 17.35 ft. (5.29 m) long, 7 ft. 7 in. (2.37 m) wide, and 6.6 ft. (2.03 m) high. Thirty people can fit inside it.

TRUE OR FALSE: ALL SHOES WERE THE SAME UNTIL LEFT- AND RIGHT-FOOT SHOES WERE INVENTED IN THE 1800S.

Actually, that's true. The idea that a shoe should only fit on one of a person's feet was a fairly recent one.

123

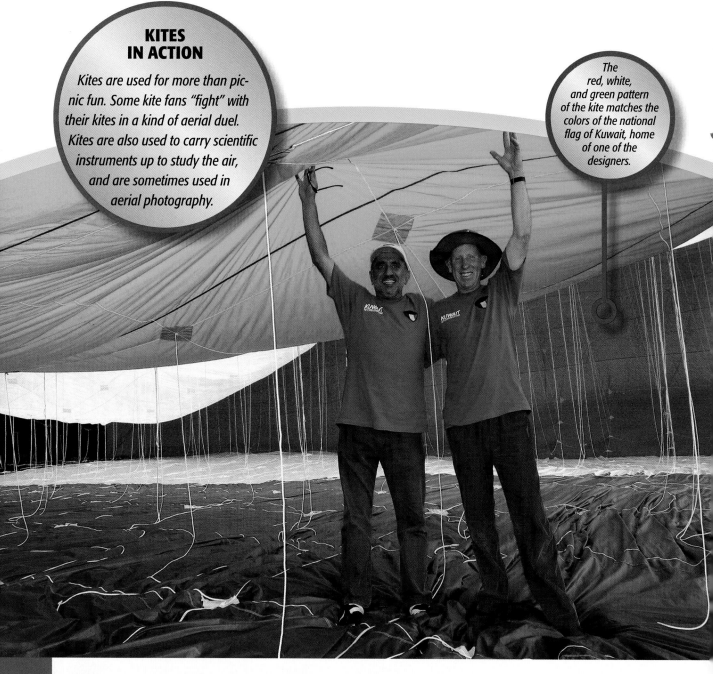

It's shown in flight on page 117.

KITES IN ACTION

Kites are used for more than picnic fun. Some kite fans "fight" with their kites in a kind of aerial duel. Kites are also used to carry scientific instruments up to study the air, and are sometimes used in aerial photography.

The red, white, and green pattern of the kite matches the colors of the national flag of Kuwait, home of one of the designers.

Pulling Strings

With a lifting area of **10,225.7 sq. ft.** (950 sq m), the **WORLD'S LARGEST KITE FLOWN** is one EFO (enormous flying object!). It's shown in flight on page 117.

The kite was made by Abdulrahman Al Farsi and Faris Al Farsi, shown here inside the kite, and flown at the Kuwait Hala Festival in Flag Square, Kuwait City, Kuwait, on February 15, 2005.

Laid flat, it has a total area of **10,968 sq. ft.** (1,019 sq m). It measures **83 ft. 7 in.** (25.475 m) long and **131 ft. 3 in.** (40 m) wide.

WHO "DISCOVERED" ELECTRICITY BY FLYING A KITE IN A STORM?

American patriot and inventor Benjamin Franklin, in 1752.

It's "Wheely" Big!

Have you ever had to haul around, say, a dozen of your closest friends? And have you ever needed a giant wheelbarrow to do it? Well, then you're in luck, because a contraption much like the one shown here is the **WORLD'S LARGEST WHEELBARROW**.

The record-holder was built in 1999 by Miles Lay, owner of the Cowpasture Barbecue near Possum Kingdom Lake in Texas.

It (the wheelbarrow, not the barbecue) was **12 ft.** (3.6 m) long, **6 ft.** (1.8 m) wide, and **3 ft.** (.8 m) tall.

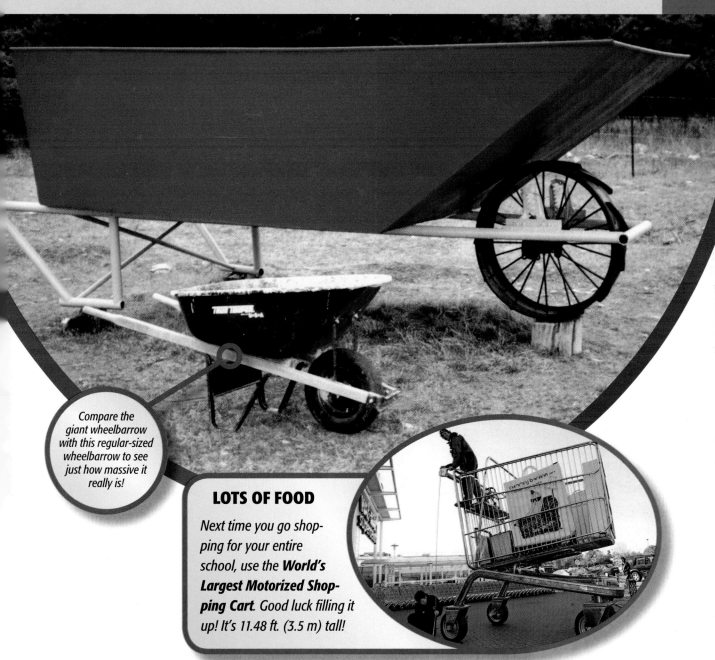

Compare the giant wheelbarrow with this regular-sized wheelbarrow to see just how massive it really is!

LOTS OF FOOD

*Next time you go shopping for your entire school, use the **World's Largest Motorized Shopping Cart**. Good luck filling it up! It's 11.48 ft. (3.5 m) tall!*

TRUE OR FALSE: THE WHEELBARROW WAS INVENTED IN FRANCE IN THE 1200S.

False: Wheelbarrows were in use in China by at least 100 B.C.E. They did first appear in Europe in the 1200s.

125

Record King

The name Ashrita Furman appears in the Guinness World Records book more than any other single recordholder. He has set a lot of those records on a pogo stick, including the **FURTHEST DISTANCE ON A POGO STICK**. In 1997, he pogo-ed **23.11 mi.** (37.18 km) in New York City. He also holds records for **MOST POGO JUMPS IN A MINUTE**, **206**, and **FASTEST MILE ON A POGO STICK** in **12 min. 16 sec.**

It's not just pogos, either. Among his other records, he also ran the **FASTEST MILE WITH A MILK BOTTLE BALANCED ON THE HEAD** in **7 min., 47 sec.**

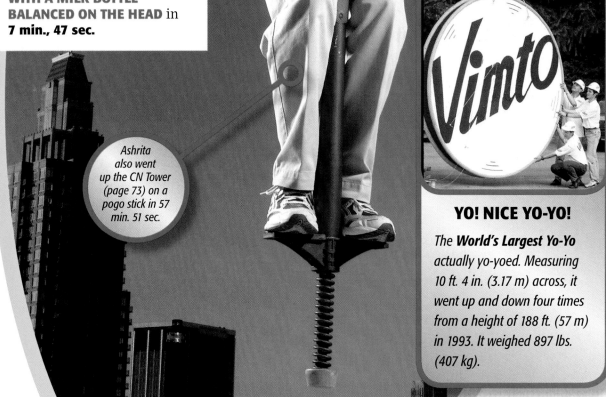

Ashrita also went up the CN Tower (page 73) on a pogo stick in 57 min. 51 sec.

YO! NICE YO-YO!

The **World's Largest Yo-Yo** actually yo-yoed. Measuring 10 ft. 4 in. (3.17 m) across, it went up and down four times from a height of 188 ft. (57 m) in 1993. It weighed 897 lbs. (407 kg).

TRUE OR FALSE: THE YO-YO WAS INVENTED IN THE 20TH CENTURY.

False! Yo-yos were used centuries ago in the Philippines. Filipino Pedro Flores did help make them popular in the U.S. in the 1920s.

An Island Giant

Colorful clothing has been a part of the tropics for centuries, but the first "Aloha" or Hawaiian shirts were not made until the 1930s. A very smart Honolulu businessman named Ellery Chun used lefotover kimono fabric to make the first ones.

They are now worn around the world and created in thousands of patterns. But among all those shirts, the one shown below is the **WORLD'S LARGEST HAWAIIAN SHIRT**. It was made in 1999 by the Hilo Hattie company. It's a—get this—size 400 XXXL!

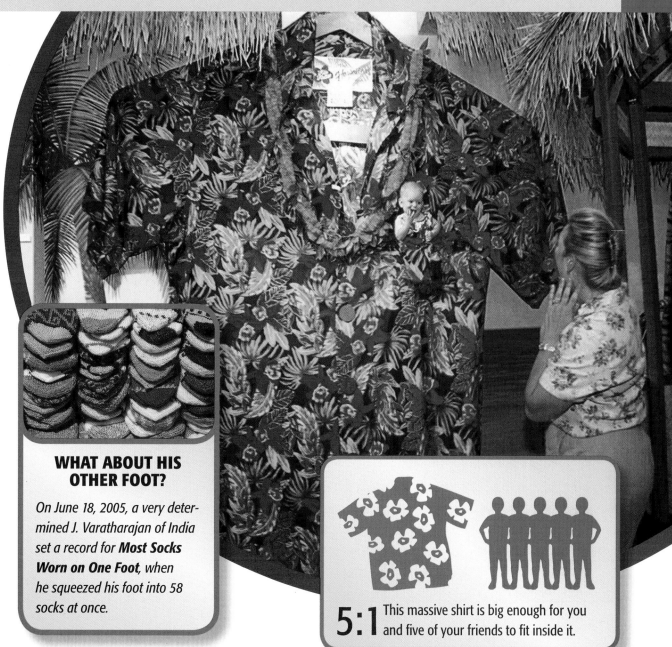

WHAT ABOUT HIS OTHER FOOT?

*On June 18, 2005, a very determined J. Varatharajan of India set a record for **Most Socks Worn on One Foot**, when he squeezed his foot into 58 socks at once.*

5:1 This massive shirt is big enough for you and five of your friends to fit inside it.

THE HAWAIIAN ALPHABET HAS AN UNUSUAL FEATURE INVOLVING THE NUMBER 12; WHAT IS IT?

The language's alphabet has only 12 letters: A, E, H, I, K, L, M, N, O, P, S, W.

127

Flame On!

For spectacular effects, few carnival skills beat fire breathing. A brave and skilled performer holds up a torch and, like a medieval dragon, shoots a jet of red-hot flame into the sky. The best fire-breathers can light up a room over and over again (though you might not want to grab a front-row seat!)

Former record-holder Robert Milton, a British performer, lights up our pages with this glowing tribute to his art. However, he is no longer the blower of the **WORLD'S HIGHEST FIRE BREATHING FLAME**.

On June 19, 2005, on the set of the TV show *Guinness World Records* in Australia, Tim Black set the record when he blew a flame to a height of **17 ft. 8.52 in.** (5.4 m).

THE SECRET

How do fire breathers do their stuff? Easy, they just eat a very spicy meal! No, just kidding. They put special flammable (and dangerous) liquids in their mouths and then spew it out across a flaming torch. The force of their blow makes for huge displays like this one.

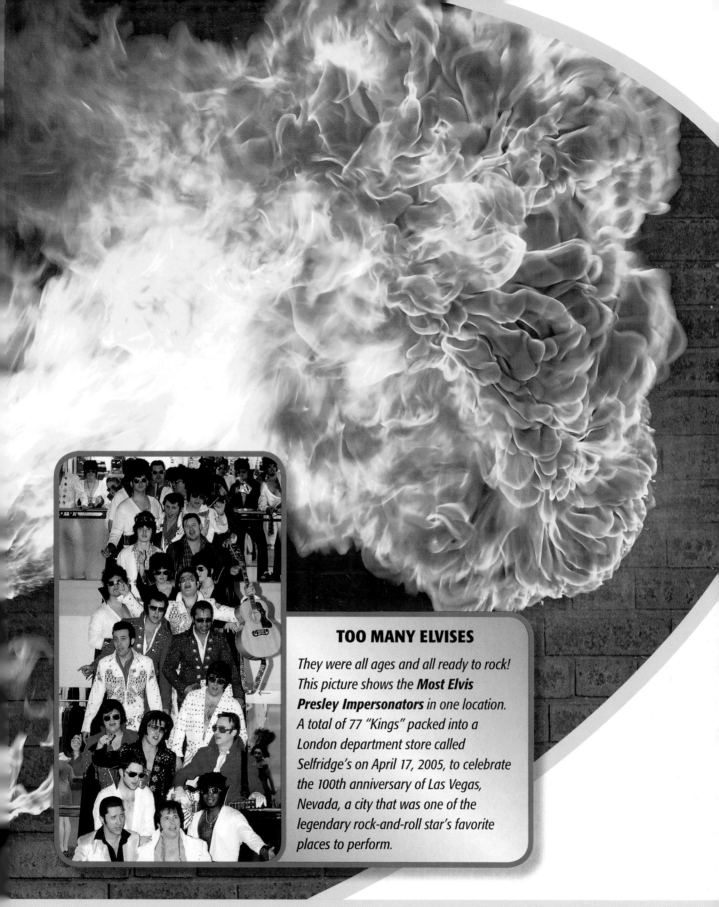

TOO MANY ELVISES

*They were all ages and all ready to rock! This picture shows the **Most Elvis Presley Impersonators** in one location. A total of 77 "Kings" packed into a London department store called Selfridge's on April 17, 2005, to celebrate the 100th anniversary of Las Vegas, Nevada, a city that was one of the legendary rock-and-roll star's favorite places to perform.*

WHAT IS THE NAME OF ELVIS PRESLEY'S HOME IN TENNESSEE THAT IS NOW A POPULAR TOURIST ATTRACTION?

Millions of fans annually visit Graceland, Elvis's home in Memphis, Tenn.

Why can't I read the screen? Well, you could if you could read German!

BIGGEST CELL PHONE USERS

According to the CIA World FactBook, these are the countries with most cell-phone users (and these numbers are growing every day . . . one report says that 3.2 BILLION people will use them by 2010!). Of course, all the phones they use are smaller than the one shown on this page!

COUNTRY	CELL PHONES IN USE
China	269,000,000
United States	202,000,000
Japan	88,658,600
Germany	64,800,000
Italy	55,918,000
Brazil	46,373,000
France	41,683,000
South Korea	33,591,800
Mexico	28,125,000
India	26,154,000

Cell-sational!

GRAB BAG

The first portable phones were the size of a brick. They've gotten smaller ever since, and today can fit in the palm of your hand. In a change from this trend, some creative engineers (and marketers!) in Germany created this purse- and pocket-busting device, the **WORLD'S LARGEST WORKING CELL PHONE**.

Built in 2004, the massive Maxi Handy phone in Bayreuth, Germany, really works! It stands **6.72 ft.** (2.05 m) high and **1.47 ft.** (0.45 m) wide, and the buttons really operate the phone, which also has an enormous color screen. Of course, since it's on a sidewalk, don't plan on having a private conversation!

IN THE TERM "CELL PHONE," WHAT DOES CELL MEAN?

Cell is short for cellular, which describes the series of small areas through which the phone's signal passes during a call.

One Big Polka

The accordion is a musical instrument often heard in polka music. Most accordions are small enough that a person can carry one fairly easily. There is even an accordion marching band that walks in parades in California.

However, they would not be able to carry this one: the **WORLD'S LARGEST ACCORDION**. Built in 2001 by Giancarlo Francenella of Italy, this playable accordion is **8 ft. 3.5 in.** (2.53 m) tall and **6 ft. 2.75 in.** (1.9 m) wide and weighs about **440 lbs.** (200 kg).

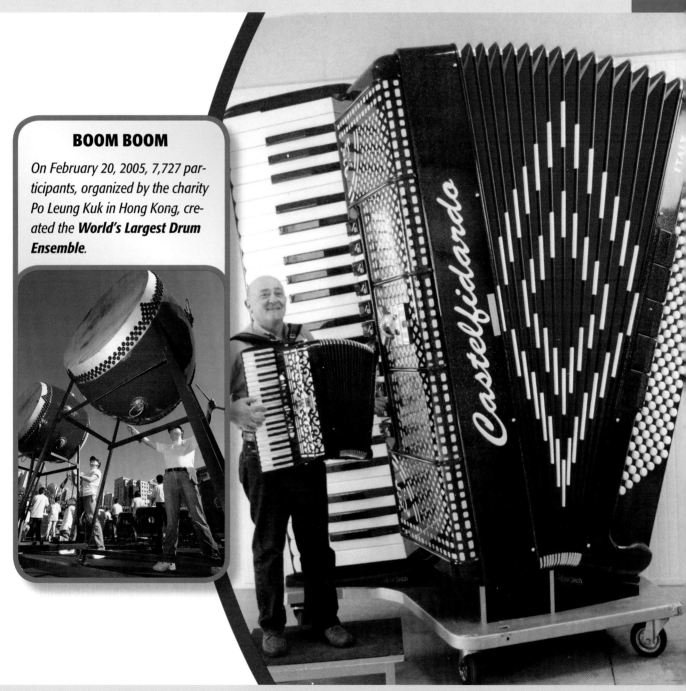

BOOM BOOM

On February 20, 2005, 7,727 participants, organized by the charity Po Leung Kuk in Hong Kong, created the **World's Largest Drum Ensemble**.

WHICH OF THE FOLLOWING IS NOT A TYPE OF DRUM: TIMPANI, SCUTTLEBUTT, SNARE?

Scuttlebutt is not a drum; it's actually a nautical term for gossip.

Super Snow . . .

It's the Ultimate "Frosty"! This colossal construction towered over the town of Bethel, Maine, in 1999. Standing **113 ft. 7.5 in.** (34.63 m) tall from the bottom of his feet to the top of his head, he is clearly the **WORLD'S TALLEST SNOWMAN**.

He had a **6 ft.** (1.8 m) nose, and 6 car tires for a mouth. He wore a **120 ft.** (40 m) scarf, and his buttons were tires from a construction machine. He even had a name: Angus, King of the Mountain (named for Maine governor Angus King)!

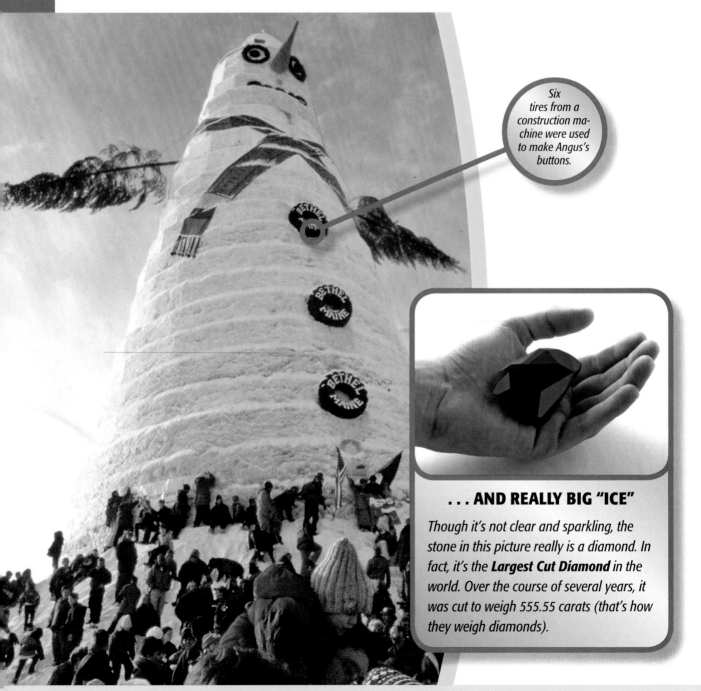

Six tires from a construction machine were used to make Angus's buttons.

. . . AND REALLY BIG "ICE"

*Though it's not clear and sparkling, the stone in this picture really is a diamond. In fact, it's the **Largest Cut Diamond** in the world. Over the course of several years, it was cut to weigh 555.55 carats (that's how they weigh diamonds).*

NOT TRIVIA, BUT A RIDDLE: WHERE DOES A SNOWMAN KEEP HIS MONEY?

In a snow bank!

Take That!

Have you ever thrown a snowball? You find some nice packing snow, form a ball in the palm of your hand, and sling it at . . . well, that's the fun part. Usually, the other end of your throw is your friend! The snowball in this picture just missed, smacking into a tree.

In 2005, an enormous group of snowball flingers **—1,548 vs. 1,536 for a total of 3,084 snowfighters—** had the **WORLD'S LARGEST SNOWBALL FIGHT**. It took place in Wauconda, Wisconsin, and was sponsored by the Wauconda Lions Club.

LET IT SNOW!

*This is a mighty big pile of snow, but it would have been barely noticed during the **World's Largest Snowfall in 12 Months**. From 1971 to 1972, 1,224 in. (31,102 mm) of snow fell at Paradise on Mount Rainier, Washington.*

IN 1999, KEITH SENDZIAK RAN 100 M IN A RECORD 13.23 SECONDS . . . WEARING WHAT?

Keith romped through the white stuff wearing snowshoes!

133

Nobody Sneeze!

Sssh! Don't move. Don't breathe. And whatever you do . . . don't sneeze! Bryan Berg is at work on another amazing house of cards. Using only carefully balanced playing cards—no glue or tape—he makes gigantic buildings. On November 6, 1999, he built a record-setter: a construction with the **MOST STORIES IN A HOUSE OF CARDS**. It had **131 stories** and stood **25.29 ft. in.** (7.71 m).

COMING CLEAN

*Using enough soap to make 26,666 Ivory soap bars, Bev Kirk created this sculpture in September, 2003. At 7,000 lbs. (3,175 kg), it is the **World's Largest Soap Sculpture**. Bev named her creation "Sudsie, a Boar of Soap."*

IF ACE IS HIGH, PUT THESE FOUR CARDS IN ORDER, HIGHEST TO LOWEST: JACK, ACE, QUEEN, KING.

If ace is high, the high-to-low order would be ace, king, queen, jack.

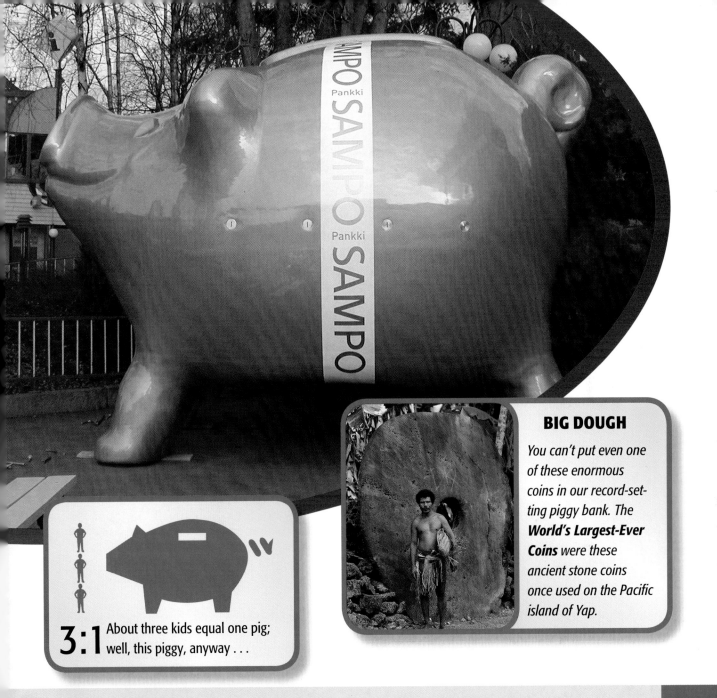

BIG DOUGH

*You can't put even one of these enormous coins in our record-setting piggy bank. The **World's Largest-Ever Coins** were these ancient stone coins once used on the Pacific island of Yap.*

3:1 About three kids equal one pig; well, this piggy, anyway . . .

A Very Biggy Piggy

How would you like to come up with enough change to fill this giant porker— the **WORLD'S LARGEST PIGGY BANK**?

This bulbous bank was made in 2003 by the Sampo Bank of Finland. It stands **12 ft. 6 in.** (3.8 m) high and is **17 ft. 5 in.** (5.3 m) long. It also has a circumference of **39 ft.** (11.9 m).

Trivia time: Do you know how piggy banks got their name? One popular story is that there was a type of clay during Europe's Middle Ages called "pygg." People used pygg to make jars and other containers. Someone who loved puns made a pig-shaped container out of pygg and the piggy bank was born.

HOW MUCH MONEY WAS STOLEN IN THE WORLD'S LARGEST BANK ROBBERY: $5 MILLION, $50 MILLION, OR $500 MILLION?

In December, 2004, more than $50 million was stolen from the Northern Bank, Belfast, UK.

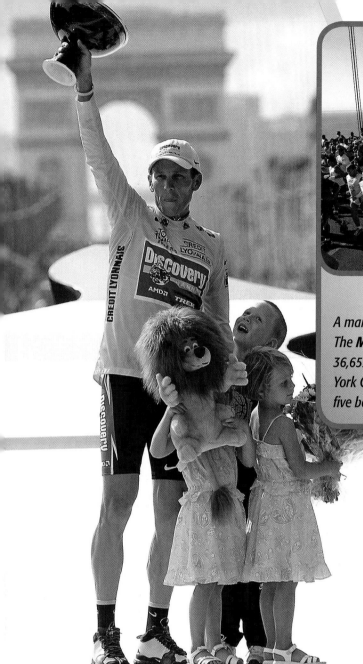

AND THEY'RE OFF!

*A marathon is a running race of 26 mi. 385 yds. (42.195 km). The **Most Marathon Competitors** was 37,357 (of whom 36,652 completed the race). They all ran throughout New York City in the 2004 New York Marathon. The race crosses all five boroughs of the city and ends in Central Park.*

WHY IS HE YELLOW?

Courageous Lance isn't yellow, of course, but his jersey is. The leader—and winner—of the Tour de France gets to wear the most famous color in cycling.

Tour de Lance

The Tour de France is one of the sports world's longest and most grueling tests. Riders pedal through the French countryside and over steep mountains for nearly a month! In 2005 American rider Lance Armstrong captured his amazing seventh consecutive Tour de France championship, making him the winner of the **MOST TOUR DE FRANCE CHAMPIONSHIPS**.

What makes Lance's record-setting accomplishment (four other racers have won five Tours) is that he had to defeat not only the mountains and the other riders, but cancer, which he beat in 1998.

WHAT CYCLIST HELD THE PREVIOUS RECORD FOR TOUR DE FRANCE TITLES BY AN AMERICAN?

Greg LeMond won it in 1986, 1989, and 1990.

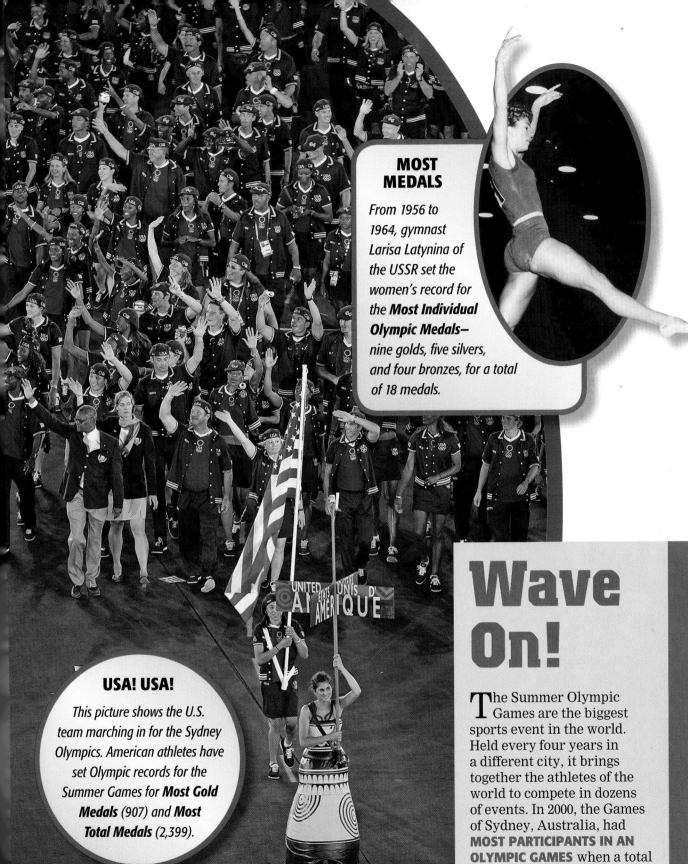

MOST MEDALS

From 1956 to 1964, gymnast Larisa Latynina of the USSR set the women's record for the **Most Individual Olympic Medals—** nine golds, five silvers, and four bronzes, for a total of 18 medals.

USA! USA!

This picture shows the U.S. team marching in for the Sydney Olympics. American athletes have set Olympic records for the Summer Games for **Most Gold Medals** (907) and **Most Total Medals** (2,399).

Wave On!

The Summer Olympic Games are the biggest sports event in the world. Held every four years in a different city, it brings together the athletes of the world to compete in dozens of events. In 2000, the Games of Sydney, Australia, had **MOST PARTICIPANTS IN AN OLYMPIC GAMES** when a total of 10,651 athletes took part.

WHEN DID THE "MODERN" OLYMPICS BEGIN, FOLLOWING IN THE GREEK TRADITION OF ABOUT 2,000 YEARS EARLIER?

The "modern" Olympics were first held in 1896 in Athens, Greece.

GOT A PEN?

You know all those pens that get lost around your house? Maybe they ended up here, in the **World's Largest Collection of Ballpoint Pens**. Angelika Unverhau of Germany lives (and writes) with more than 285,000 ballpoint pens!

LOTS OF LOST BALLS

Golfers fills their golf bags (and the rough!) with golf balls. The **World's Largest Collection of Golf Balls** belongs to Ted Hoz, who gathered up 74,849 as of 2003.

STICKING IT TO THIS COLLECTION

It must be hard to autograph a drumstick; they're very skinny! But Peter Lavinger has the **World's Largest Collection of Autographed Drumsticks** (1,300-plus) since 1980.

WANT TO PLAY A GAME?

*If you want to play a board game, Kevin Cook would be a good guy to know. Since 1977, when he started playing the Dungeons & Dragons game, Kevin has amassed the **Largest Collection of Dice**. A member of the Dice Maniacs Club, Kevin owns 11,097 dice.*

QUACK, QUACK

*It started with a few ducks in a new bathroom. More followed and soon it was a ducky flood. Now Charlotte Lee owns the **World's Largest Collection of Rubber Ducks**, more than 1,400 (since 1996).*

BASKETBALL'S SCORING MACHINE

Wilt "The Stilt" Chamberlain had the **Highest Scoring Average in an NBA Season** when he averaged 50.4 points per game in 1961–1962. One of the reasons for his record came on March 2, 1962, when he set the record for **Most Points Scored by an Individual in an NBA Game** with 100!

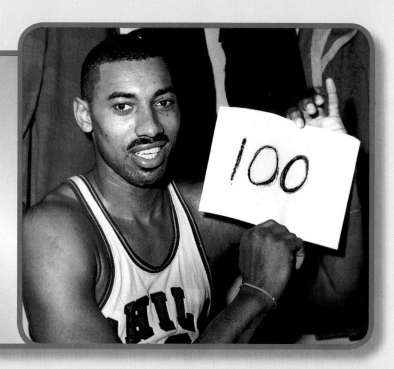

A TIGER OF A GOLFER!

Though he just turned 30 at the end of 2005, Tiger Woods has established himself as one of the greatest golfers of all time. He is third with 10 "major" championships and has won 46 PGA Tour titles. His career began in 1996; through 2005, he had set a record for **Highest Career Earnings**: $46,356,737. That doesn't include the millions he makes endorsing products.

"HAMMERIN' HANK"

With this swing, on April 8, 1974, Henry "Hammerin' Hank" Aaron set a record for the **Most Home Runs in a Career**. This was his 715th homer, on his way to a final career total of 755. Aaron is also the career leader in runs batted in (RBI), with 2,297. Not surprisingly, he was elected to the Baseball Hall of Fame.

FOOTBALL'S BIG DAY

On November 27, 1966, the Washington Redskins scored 72 points, the **Highest Score in an NFL Regular Season Game**, against the New York Giants, who scored 41, thus setting a record for **Most Points by Two Teams**, too!

FOOTBALL'S BIG DAY, PART 2

The **Most Touchdowns Scored in an NFL Game** is six, accomplished by three men: Ernie Nevers (1929), William Jones (1951), and most recently Gale Sayers, right (1965). Sayers scored on runs, passes, and a kick return.

PHOTOGRAPHY CREDITS

Thanks to the following for their permission to reproduce the photos used in this book. Every effort has been made to supply proper credit. Photos used in boxes or sidebars are shown second, where appropriate, on this list. Abbreviations of photo agencies—GWR: Guinness World Records; AP/WW: AP/Wide World; GI: Getty Images; RUSA: Rex USA.

9: GWR; 10-11: GWR, Corbis; 12-13: RUSA; 14: Corbis; 15: Sipa Press; GI; 16: GI; 18: GWR (2); 19: GWR; 20: Corbis; 21: GWR, Photos.com; 22: AP/WW, Lutz Bongarts/GI; 23: Doug Pensinger/GI; 24: GWR, AFP/GI; 25: GWR, Mark Dadswell/GI; 26: GWR, Corbis; 27: RUSA, Corbis; 28-29: Ford: Terry O'Neill/Hulton/GI, surfers: Antonio Scorza/GI, rainbow: AFP/GI, Jennings: GI; 30: Minden Pictures; 32: Minden Pictures, Brian Skerry/Natl. Geog./GI; 34: Corbis, Brian Skerry/Natl. Geog./GI; 36: Photos.com, Norbert Rosing/Natl. Geog./GI; 37: GWR, Scott Nelson/AFP/GI; 38: GWR, Donald Miralle/GI; 39: GWR, Michael K. Nichols/Natl. Geog./GI; 40: Natural History Museum, Corbis; 41: Corbis (2); 42: dreamstime.com (2); 43: dreamstime.com, Phil Walter/GI; 44: Corbis (2); 45: Mark Wilson/GI, Koichi Komashida/GI; 46: wasp: GWR, roach: Corbis, stick insect: Corbis, elephant seal: iStock, toad: Corbis; 48: RUSA; 50: GWR, dreamstime.com; 51: GWR, dreamstime.com; 52: GWR, Dimitris Dimitriou/GI; 53: Business Wire/GI, GWR; 54: GWR (2); 55: GWR, iStock; 56: GI; 58: Courtesy Wild Willy's; 59: GWR (2); 60: AP/WW (2); 61: RUSA (2); 62: RUSA, GWR; 63: Courtesy Carvel Corp.; 64: AP/WW, GWR; 65: N.L. Ford, AP/WW; 66: GWR, photos.com; 67: AP/WW, GWR; 68: toffee: GWR, garlic: AP/WW, lollipop: iStock, jawbreaker: Courtesy Oak Leaf Confections, flowers: Corbis; 70: Corbis; 72: Corbis, iStock; 74: Photos.com, iStock; 75: David Cannon/GI (2); 76: Corbis, Peter Essick/GI; 78: Tom Shaw/GI, Antonio Scorza/GI; 79: Photos.com; 80: Toru Yamanaka/GI, iStock; 81: Corbis, Al Messerschmidt; 82: Corbis, iStock; 84: Photos.com, AP/WW; 85: Photos.com, iStock; 86: Photos.com, Chien-min Chung/GI; 87: Peter Essick/GI, iStock; 88: Bill Curtsinger/Natl. Geog./GI; iStock; 89: Photos.com, AP/WW; 90: desert: Photos.com, swamp: Stephanie Maze/Natl. Geog./GI, waterfall: iStock, dome: iStock; door: Corbis; 92: Photos Essentials; 94: Courtesy Bigfoot 4X4, Tim DeFrisco/GI; 96: GWR, Courtesy Marine Turbine; 97: Jeff Haynes, Courtesy Koniggsberg; 98: Miguel Riopa/GI, iStock; 99: RUSA, Pascal Guyot/GI; 100: Corbis (2); 101: AP/WW, Amanda Edwards/GI; 102: GWR (2); 103: Corbis, AP/WW; 104: Corbis, AP/WW; 105: GWR, Jed Jacobsohn/GI; 106: Mark Mainz/GI, Frank Peters/GI; 107: Paul Kane/GI, Nick Laham/GI; 108: Paul Broben/GI, GI; 110: Courtesy IT&E, iStock; 111: Corbis, Hulton/GI; 112: Time & Life/Yale Joel/GI, GI News/GI; 114: hovercraft: Adrian Dennis/GI, train: iStock, Gordon: Nick Laham/GI, Lessing: Robert LaBerge/GI, tanker: Courtesy Aike Visser; 116: RUSA; 118: GWR; 119: GWR (2); 120: Corbis; 121: AP/WW, GWR; 122: GWR, Joe Raedle/GI; 123: GWR, AP/WW: 124: RUSA; 125: GWR, RUSA; 126: GWR (2); 127: AP/WW, iStock; 128: GWR, Chris Jackson/GI; 130: GWR; 131: GWR, Peter Parks/AFP/GI; 132: GWR (2); 133: GWR, Corbis; 134: RUSA, GWR; 135: GWR, Corbis; 136: AFP/GI, Spencer Platt/GI; 137: Jonathan Ferrey/GI, Hulton/GI; 138: golf balls, ducks: dreamstime.com, drumsticks: GWR; pens: dreamstime; soccer balls: Christof Koepsel/GI; 140: Sayers, Woods, Aaron: Getty, Redskins, Chamberlain: AP/WW.

Illustrations by Bob Eckstein.

ACKNOWLEDGMENTS:

The producers would like to thank Peter Harper and Alexandra Bliss of Time Inc. Home Entertainment for their generous assistance in the preparation of this book. Laura Plunkett and Laura Jackson of Guinness World Records Limited were invaluable in helping gather information and photography.